# Kenneth Martin

Introduction and Notes by Andrew Forge

Yale Center for British Art   New Haven 197

**This catalogue was published on the occasion of an exhibition
at the Yale Center for British Art, New Haven, Connecticut**

**April 18–June 17, 1979**

| | |
|---|---|
| **Photography** | A.C. Cooper: 14, 15, 20, 23 |
| | Chris Davies, Report, London: Kenneth Martin photo |
| | Martin Koretz: 25, 26, 28 |
| | Michael Marsland: 44 |
| | John Pasmore: 19, 21, 22 |
| | Prudence Cumming Associates: 47, 48, 51–55, 70, 73 |
| | Johan Severtson: 3, 10, 27, 29, 31–36, 59, 65–69, 71, 72 |
| | John Webb: 7, 8, 24, 61, 62 |

| | |
|---|---|
| Typesetting | Southern New England Typographic Service, Inc. |
| Type | Univers 45, Univers 65 |
| Printing | The William J. Mack Company |
| Binding | Mueller Trade Bindery |
| Design | Johan Severtson |
| Cover | Painting: Chance and Order 18 (Black) 1974 |

Copyright © 1979 by the Yale Center for British Art
ISBN 0-930606-16-7
Library of Congress Catalogue Card Number 78-68853
Printed in U.S.A.
At the direction of the Yale University Printing Service

# Contents

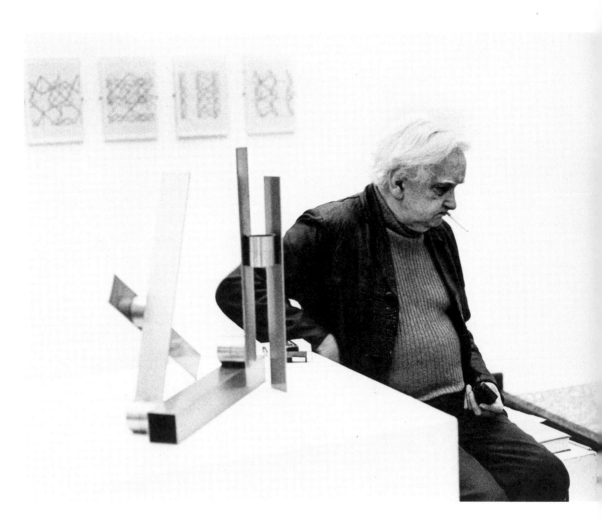

photo Chris Davies, Report, London

# Foreword

Abstract art is truly objective, not 'non-objective.' The object which is created is
real and not illusional in that it sets out to represent no object outside the canvas,
but to contain within itself the force of its own nature. And the painter seeks to be
wholly intelligible in thus objectifying his subjective self. He attempts to create a
universal language as against a private language.

<div align="right">From ABSTRACT ART, London, 1951</div>

Kenneth Martin wrote this statement in 1951. Trained in the realist tradition of Sickert,
Martin came to abstraction in the late 1940's after working as a designer and painting
naturalistic pictures for two decades. In the thirty-odd years since then, the artist has
sought not only to redefine abstract art, but to seek ways to imbue it with new
meaning—in his words, to align thought, feeling and imagination with the methods of
making a work of art. In the process, the artist has established himself as a critical figure
in the post-war revival of abstract art in England. Moreover, his art has evolved and
changed as he discovered new means of inventing, or manipulating, basic structural
elements.

"Since my first abstract works," the artist has written, "I have been concerned with
the mental and physical process of making a work of art. In fact, the first SCREW MOBILE is
a manifestation of this interest in its most primitive form." Like his SCREW MOBILES,
Kenneth Martin's sculpture of the early fifties investigates the dynamics of movement,
exploiting the tension, or opposition, between rest and the changes effected by the
basic functions of twist and rotation. His paintings of the same period deal with similar
problems by opposing orthogonals and curves within simple geometric shapes of un-
modulated color. Manifesting his fundamental interest in movement and process, his
successive works from the late fifties and early sixties, like his LINEAR CONSTRUCTIONS and
OSCILLATIONS, are the result of rhythmic programs based on the study of mathematical
ideas. In his more recent works, especially those produced over the last ten years, the
artist has explored the specific relationship of chance and permutation in the creation of
a work of art. This series, which the artist appropriately calls CHANCE AND ORDER, repre-
sents the furthest his art has progressed in the direction of a conceptual art form and it
is this series, the bulk of which are drawings in which the program is empirically discov-
ered (and written on the drawing) and then elaborated, which seem to be the culmina-
tion of his earlier efforts and to be of greatest importance for the course of current
abstract art in America and Europe.

This exhibition, which celebrates the artist's 74th birthday, marks the first opportu-
nity for his work to be seen in depth in this country. Given the quality of the artist's work
and its parallels, both formal and theoretical, with contemporary American art, this is an
event of importance. A fellow artist (a Frenchman) has attributed the artist's relative lack
of international recognition to the accident of his having been born in England rather
than in America. The exhibition, we hope, will somewhat redress this situation.

<div align="right">Edmund P. Pillsbury, Director<br>Yale Center for British Art</div>

## Acknowledgments

The idea for this exhibition owes itself to Andrew Forge, Dean of the Yale School of Art. As a friend of the artist and author of several articles about him, including a perceptive essay on the artist's writing which appeared in the two-volume catalogue for the retrospective exhibition of the artist's work held at the Tate Gallery in 1975, Dean Forge was ideally suited to serve as guest-curator of the exhibition. The essay he has written evokes the warmth and subtlety of the artist's mind and establishes his place in the context of British art.

Naturally an exhibition of this kind required the assistance of many individuals. We are particularly grateful to the artist for his enthusiastic acceptance of our proposal to organize the exhibition and his invaluable assistance in the selection and installation; to Leslie Waddington and his assistant Sarah Tobias, for their patient and efficient handling of many details related to the borrowing of works and to preparing the catalogue; and to the many lenders who generously agreed to participate in the project. Thanks are also owed to Johan Severtson, a graduate student of the Yale School of Art for the new photographs he took of the artist and his work and assistance in designing the catalogue and installation; to Greer Allen of the Yale Printing Service, who oversaw the design and production of the catalogue; to Joyce Giuliani, the Center's Registrar, who supervised the transport of works and many other details related to the preparation of the show and its catalogue; and finally to Richard Baronio, Chief Exhibit Designer at the Center, and his staff for the care they took in installing the works and fabricating the necessary mounts and labels. Without their help this tribute to an artist of uncommon distinction would not have been possible.

E.P.P.

# Introduction

Kenneth Martin was born in Sheffield, Yorkshire in 1905. His parents came from the southwest of England. At the time of Martin's birth his father was a clerk. When Martin was sixteen he enrolled in the School of Art in Sheffield where he began a traditional training in painting and drawing, traditional in the sense that it went on as though Cézanne had never existed. After two years his father died and he had to leave school and find work. For some years he worked as a designer, meanwhile continuing to paint and to read widely. His room became a gathering place for the livelier students at the art school. In 1929 he gained a scholarship to the Royal College of Art and went to London.

The Royal College at that time was the gateway to any kind of career in art teaching in England, but it had little to offer Kenneth Martin. "The only thing I learned at the Royal College," he said in retrospect, "was when Will Rothenstein allowed me to go and copy at the National Gallery." A copy of Poussin's NURTURE OF BACCHUS still exists and he worked from other painters, laying the foundations of his incomparable knowledge of pictures. It is characteristic of all his life that he should have gained the most important lessons independently.

The Royal College was important for another reason. It was here he met and married Mary Balmford, a gifted and highly intelligent fellow-student who was to be the most important influence in his life. Their development as artists proceeded side by side. The crucial turn toward abstraction was argued out between them. His flights of speculation, his struggle to find ways of articulating his ideas took place against the background of her dry common sense, and often the logic of her work suggested possibilities he had overlooked in his own. More than once they collaborated publicly. Mary died in 1969.

Their life was extremely hard for many years. Nobody could expect to live by painting in England during the 1930s. During much of the war Kenneth Martin was in an air raid rescue team in London. In the late '40s they moved into a basement flat in Swiss Cottage where they raised their two sons and did their work. Shortly after the war Martin had begun to teach in art schools and this was to be his main livelihood for many years. He was a brilliant teacher. He belongs to that family of artists to whom ideas are of cardinal importance, and whose view of art is in a state of continuous growth. Yet his teaching is always practical. Any classroom he was in became his own studio. Something of the range and intensity of his teaching (though not always its warmth) can be picked up from his writing, of which he has done a great deal.

One of the places where he taught for a few years immediately after the war was Camberwell School of Art in South London. Among his colleagues there were William Coldstream and Victor Pasmore. Kenneth Martin had got to know them during the '30s and had something in common with their position. What this amounted to was first a suspicion that the school of Paris was decadent and given over to a fashionable avant-gardism. What was called for, they said, was a rejection of the cult of originality, of "genius," of anything that could be called "arty." Instead, Coldstream suggested, it was time to look again at the impressionists' claim to have been painting what they saw. In his own painting Coldstream worked rigorously and over long periods from observation from a fixed point of view. Every mark he made represented an interval or a direction in a plane at right angles to the visual cone. Theoretically this plotting took place without any aesthetic bias; and indeed, without representational bias either. That is to say, likeness accrued as an almost involuntary result of the plotting, not the other way round. Kenneth Martin was sympathetic to the rigor of Coldstream's position. He was interested in measurement and in the attempt to find an objective framework within which to canalize his imagination. He shared nothing of Coldstream's conservatism.

**8**    By the late '40s Kenneth Martin had begun to question this enterprise. He began to look at those aspects of Post-Impressionism which had been concerned with isolating and ordering the elements of painting themselves. He looked at late Degas, Seurat, Gauguin, and above all Van Gogh, meanwhile reading anything he could find on the theory of color and the geometry of design. His work became increasingly formal. He had made a long series of pastels and paintings of a view over a railway cutting not far from where he lived in which the observed data provided little more than an armature for his flat color combinations. He realized that these works were not saying enough about what he saw. The specificity of the place had been refined away. At the same time, vestiges of representation were preventing the painting from coming into its own on its own terms. Abstraction from appearances seemed inevitably to attenuate the meaning of those appearances. He began to see that there was the possibility of working in the opposite direction—not distilling simple forms from complex data but starting with simple elements and working toward complexity through a constructive process. This was unknown territory to him, only vaguely apprehended; but its offer was convincing.

There was no Museum of Modern Art in London, no Peggy Guggenheim, no Katherine Drier. There was remarkably little interest in or sympathy for abstract art which many people thought of as an historic experiment which had largely been played out—this in spite of Ben Nicholson, or the fact that Mondrian and Gabo had been working in England only a few years earlier. Kenneth Martin and a small group which included Mary Martin, Victor Pasmore, Robert Adams, Anthony Hill, and Adrian Heath began to work together, putting on group shows and publishing statements. Their activities aroused a good deal of notice, mainly because of Victor Pasmore. His recent painting, exquisite landscapes and interiors in which both Whistler and Bonnard gave nourishment to an extraordinary lyrical talent, had become the object of a considerable vogue. Pasmore's move into abstraction, led him, for a while, to give up painting altogether. This was regarded by many of his admirers as a betrayal and aroused a good deal of bad feeling. Kenneth Martin had less to lose at that time. All the same, he knew that he was cutting himself off from many long-standing connections.

He now embarked on an extended search for information, reading whatever he could find in science and mathematics, his knowledge of which was limited in a technical sense but for whose concepts he had an infinite appetite. He spent long hours in the Science Museum and its library at South Kensington, studying the three-dimensional models of mathematical formulae and reading of the new geometries, and, in the Natural History Museum, exploring the morphologies he had found discussed in the pages of D'Arcy Thompson. To some extent his guide in these explorations was Paul Klee whose theoretical writings Kenneth Martin admired. In particular, Klee had shown him the importance of process and had opened up a range of formative principles which had freed him from apprenticeship to the *look* of existing abstract art. From now on he was to work from the process to the object, from the forming to the form, never the other way round. This meant to work with simple elements, additively. The simplest beginnings yielded a rich repertoire in which number, sequence, interval, and rhythm could be considered in isolation and in relation to a general principle. The work grew as a sum of all the decisions made along the line of that principle; neither aiming at a look nor responding to the schemata of art, hackneyed or otherwise.

The range of Kenneth Martin's search for "hard" determinants in his art tells us a great deal about him. It has never been enough for him merely to think of his art within the context of the art world. He has always needed to look for broader connections. His work is, in a sense, philosophical. This is the scale of the value that he places on the constructive idea. We can sense this in his writing which is essentially pedagogical. When, as he often does, he writes about "the constructive artist" in the third person, we know that he is referring not only to himself but also to an ideal exemplar who stands for a wide cultural responsibility and to whom he, Martin, owes allegiance. Constructive art

is a high and ambitious commitment.

Unlike Mondrian, he did not try to persuade himself that the new way announced Utopia. For him it promised even closer access to the world as it was. Nor did the new preoccupation cut him off from earlier art: just as he began to see nature with a new precision and a deeper meaning, so he rediscovered features in Signorelli, Titian, Leonardo, de Hooch, Rembrandt, and a host of other painters which persuaded him that his new insights connected with perennial concerns in the tradition of art. His first abstract painting was made in 1948. Soon he was working in three dimensions, using wire, wood, and cut metal. He had to teach himself the basic techniques of soldering, brazing, welding, and turning. The move into workshop materials was shared by Mary Martin, Pasmore, and later by Hill. The rationale for it was to be found in the history of Russian constructivism and in the immediate influence of the writings of Charles Biederman and the work of Vantongerloo with whom they were in personal contact. Theory apart, there was a strong pragmatic reason, namely, the need to cut himself away from the illusionism inherent in painting and to assert the new objectness of his work. Cutting, bending, joining, he was discovering *as a painter* the sculptor's special contact with the real. Throughout the 1950s and '60s his main effort was in three dimensions, and although he has always insisted on the unity of his work in all its aspects, it was as a sculptor that he became known internationally. More recently painting and drawing have again taken first place in his work; but this is in no way a departure from a line of thought which started with his first mobile.

This was made in 1951. It was an event of great importance in the development of his ideas, not only because of the rich possibilities of a form unfolding in space and time but because of the simple necessities of its construction. Real materials, the actual behavior of joints, hinges, points of articulation, gravity, wind, light: all entered his work now as formative agents. To the painter become sculptor the limitations inherent in three dimensions have a special excitement. On paper a line can be pushed in any direction. A wooden dowel could only do certain things. It was limited by its physical nature. This limitation became a source of energy:

> Each work can grow outwards by proportion, like a tree repeating its form, or a bridge arriving at a final and complete form. . . . Proportion becomes functional again . . . not as an academic principle or a beautifier, but capable of rendering precise ideas and of assisting in the development of new ideas.[1]

Since then each new departure has been both formative and questioning: "concept and material go hand in hand. Material can inspire—concept dictate material—material qualify concept." The fact that the first three-dimensional works were mobiles and introduced at one stroke certain mechanical necessities, as well as the real elements of light and shadow, gravity, and time, precipitated him into a new world in which, it must have seemed, there was no limit to the discoveries waiting to be made. Above all there was the power of the organic process itself, leading from the simplest beginnings to results of unimaginable complexity:

> I believe that this is fundamental to the constructivist idea. That the work is the product of the simplest actions. It is not a reduction to a simple form of a complex scene before us, it is the building by simple events of an expressive whole. Our tools are like the notes on the piano. We can start with a simple sequence, we can order it according to one or two simple rules, the result can be like a fugue. That rests with the artist."[2]

The first mobiles were made of series of rods, each of which was suspended horizontally from the one above. They swung freely within limited but fluid combinations of

[1] Kenneth Martin, "An Art of Environment," BROADSHEET NO. 2, privately printed, 1952.
[2] Kenneth Martin, "The Development of the Mobile," 1955. Published, KENNETH MARTIN, Vol. I, Tate Gallery, London, 1975, p. 7.

orbits, sometimes stretching far, sometimes closing up tightly. In spite of the simplicity of their construction, they offered complex readings which became further elaborated when he began to attach metal discs to the ends of the rods, some colored, some mirrored. Then there was a further series called LINKAGES in which both ends of the horizontals were suspended, giving a cranking and opening and shutting motion of great beauty.

In 1953 he began to explore a new form which he called the SCREW MOBILE. In its simplest form this is a vertical metal rod with horizontal bars brazed to it at regular intervals. When it spins, the eye sees a solid of revolution with a changing kinetic contour. Every aspect of these spiral forms could be seen as subject to separate, clear-cut decision: the length of each horizontal, the width of the material it was made of, the angle at which it was set in relation to its neighbor, the direction of the spiral, clockwise or anticlockwise, the distance between each piece. Working with this limited number of variables he could invent an ordering system—the rules of a game which he would "play out" to its conclusion on the drawing board. The drawing would act as a template for the mobile which would grow from it. Later forms of the series are made more complex by the addition of further elements to the ends of the horizontals, thus introducing a counterpoint of spiral themes.

The invention of these spiral mobiles was of crucial importance in his development and much of his later thinking is due to them. It was by far the richest, most complex form that he had made. The form was pregnant: each version revealed its own special identity, its own kind of life. Something happened here which was paradoxical, mysterious, and stirring—yet it was the outcome of a train of thought that was not in itself addressed to paradox, mystery, or emotion.

The form itself could be considered as perfect, totally consistent within its own laws yet potentially infinite. Each aspect of its movement was distinct and evoked its own special range of feeling. Downward, the spiral will bore swiftly, like an augur, joining its energy with gravity. Its upward movements soar, flicker with sudden changes of tempo, pirouette weightlessly as if defying gravity. But it is above all in the discrepancy between the stationary form and the moving form that the content of these works seems finally to lie. Contemplating the relationship between what can be understood about the thing as a structure and what can be perceived as a phenomenon, we are brought into a state of peculiar awareness. The still form is the logical product of an additive process, not always so simple but at least capable of rational analysis. The perceived character of the work, from its existence as a swept volume existing only in perceived time, to such surprising details as the play of light up and down its brass surface and the waxing and waning of its shadow—all this takes on the quality of a prodigal florescence out from the bare and disciplined idea of its making.

The spiral form is both closed and open, finite and endless. Recognizing its symbolic force, Kenneth Martin was to write about it as one of the "... primary attributes of nature used by artists from remote times to the present to express their position in and attitude towards the universe."[3] The spiral symbolizes "dynamic and aspirational forces" and everything that is beyond comprehension, just as the crystalline stands for perfection, "the very refinement of order from which deviations are errors." But he is no longer concerned with formal perfection, rather with a forming process which itself corresponds with his view of life. "Life is variable and inevitable, recurrent and developable. For the individual it is essentially tragic."[4] And:

The work of art is never only a series of pure relationships; it is related to life. We

[3] Kenneth Martin, "Construction from Within," STRUCTURE, 6-1, Amsterdam, 1964. Republished, KENNETH MARTIN, Vol. I, Tate Gallery, London, 1975, pp. 12-13.
[4] Ibid., p. 12.

may observe this immediately and directly through parallels with nature and with our own make-up. But it may go deeper, to dig things out of us. It is these correspondences which are important, which words can only express through poetry, which Mozart understood in music. These direct relationships of the physical and the spiritual within us.[5]

The first linked and reflector mobiles had been ordered in their structure but open to chance in their movements. Currents of air, the touch of a hand, would produce a continuous and unpredictable unfolding of form. Martin became increasingly interested in indeterminacy and in the framework within which variations could be given free range. About 1965 he began working on a long series of structures which could be adjusted by the onlooker: the TRANSFORMABLES (1966), ROTARY RINGS (1967), the VARIABLE SCREWS (1967–74) and the STANDING LINKAGE (1970). In all these the onlooker could manipulate the piece himself, altering its relationships and, in so doing, not merely discover his preferred arrangement but the ordering principles according to which it was made. The variable mobiles had a threaded central axis which allowed for the adjustment of the elements of the mobile; this meant that the participant became involved in balancing it and hence in the forming role of gravity.

This was the theory at any rate. Reflecting on it in a long paper published in LEONARDO, Kenneth Martin expressed reservations about the level of response that he could expect from this:

> But on the other hand, is the search for the one and only solution, for the finite rightness of each part to the whole, the most important task . . . ? The kinetic artist is interested primarily in work whose realness is expressed through change as movement.[6]

The realness of the work, in fact, was experienced in the deep structure of the piece and this only became clear through the playing out of its endless surface variations.

The issue of indeterminacy within an exact conceptual framework was taken further in the long series of drawings, paintings, and prints called CHANCE AND ORDER which has occupied much of Kenneth Martin's attention during the past nine years. In the simplest versions, a grid is set up on paper and its points numbered. Corresponding numbers are then drawn by lot in pairs. Each pair then becomes a line on the grid. Obviously no two drawings are the same, although the underlying structure remains the same in each sequence. It is as though that obscure dialogue which accompanies all art, between the idea and the object, is itself conceptualized and brought into clear focus. Each work can be seen as a single state isolated in a stream of possible states, both an example and a unique resting place.

I have emphasized the conceptual and systematic side of Martin's work for obvious reasons. I must now insist that he is no dispassionate ideologue. On the contrary, his search for order has intensity precisely because he is no stranger to its opposite. He knows as much about doubt and anxiety as anyone and a good deal more about wildness and amazement than most. His internal campaign against "the arty" and the cult of self has been waged so fiercely and for so long, not out of any rejection of life and imagination, but because it seemed to him that the latter-day romanticism on which so many of the assumptions of modern art are based is a betrayal of those very things. And the same is true of his dismissal of avant-gardism, of modernist historicism. The modern movement is heroic to him and not to be reduced to fashion. He has been at odds with fashion for most of his life and I doubt that he would be convinced of fashion's good sense if fashion suddenly went his way.

---

[5] Kenneth Martin, "Means and Content (in the abstract, constructed work of art)," Unpublished paper, 1964.
[6] Kenneth Martin, "Construction and Change," LEONARDO, Oxford, Vol. I, October 1968. Republished, KENNETH MARTIN, Vol. I, Tate Gallery, London, 1975, p. 37.

The importance of system to him is that it is precisely a framework for clear either/or decisions, for engagement with materials, for boredom and hence for play, and the darting, restless imagination, perversity, the ebb and flow of energy, curiosity, delight. Just as play mirrors life symbolically, so the ground for play in art symbolizes the artist's moral stance toward the world and his psycho-physical makeup. His delineation of that ground for play will be achieved through his own honesty and the awareness with which he relates himself to the world.

Kenneth Martin's sensitivity to and delight in his surroundings is extraordinary. To be with him anywhere—at the window of a train, in a Gothic cathedral, crossing a square or a busy street—is to be drawn into an endless adventure. Everything has to be counted, matched, compared, likened, contrasted; every change of scale, of incline, of surface, every opening or closure, every shift has to be explored. His eye is always looking for pathways, for varieties and families of movement. He is strongly aware of how the body's feeling for wholeness and its own articulation projects itself into the outside world; and how the outside speaks back to us and finds its lodgement in our bodies. He finds architecture everywhere. He has described some of his works as "an architecture in epitome," thus warning us against seeing them as maquettes or models.

> Seeing the Maison Carré at Nimes or the Frauenkirche at Nürnberg for the first time I feel as if I could pick them up and put them in my pocket. Scale, that of the parts to the whole, of the whole to the environment and to oneself, speaks to one. It is not necessary always to be formidable.[7]

And:

> In the work of art scale is more important than size . . . Things themselves, their relationships together and that of the parts, are all related to us, to the different parts of our senses. The touch of the palm is different from that of the fingers, while the eye can explore both near and far. . . . Miniaturization can hold the attention as much as the large edifice—similarly and differently. . . . We are not satisfied with the open stare but need the inquisitive look as well. On the large desolate plain one looks for a point of interest. The eye can go where the touch cannot and can adjust itself to a new scale.[8]

A.F.

# Selections from the Artist's Writings

## On Art and the Environment

Constructive or concrete art is a manifestation of the modern spirit. It is not merely a derivation from past ideas or an imitation of past manners but an alliance with contemporary scientific developments, an exploration of the present and the rendering in visible terms of aspects of modern thought. In the past, realism could play such a part, but today realism and the techniques which have developed with it are no longer adequate to express new concepts.

[7] Kenneth Martin, "Scale and Change," STUDIO INTERNATIONAL, London, January 1970. Republished, KENNETH MARTIN, Vol. I, Tate Gallery, London, 1975, p. 42.
[8] Kenneth Martin, "Construction and Movement," ART INTERNATIONAL, New York, Summer 1967. Republished, KENNETH MARTIN, Vol. I, Tate Gallery, London, 1975. pp. 23–24.

In contrast to this decline of realism (the work of art, having been freed by abstraction from the necessity for representational elements) the new artist has been given the means to create a new object, instead of the appearance of an object, and to organize real space, instead of illusional space.

The discovery of true perspective, which enabled the painters of the renaissance to represent the illusion of solid bodies in space, weakened those symbolic properties of mathematical proportion which had developed until that time and, although proportion continued to assist in the organization of works into complex and significant unities, its chief role diminished to that of a beautifier.

While the cubists dispensed with perspective they restored fully to mathematics its constructional role, reviving earlier systems of proportion and using them as means of pictorial architecture, and established more firmly the picture as a form. In so doing however, this pictorial architecture assisted in the distortion of the appearance of objects in such a way as to misdirect much of modern painting. Distortion became an end in itself and the consequence in that direction has been confusion.

On the other hand, the abstract artists have developed the work of art as a symbolic object, so that, while at the hands of the modernists appearance has become unreal, the object created by the former has become concrete.

It is this real concrete object which is the concern of the constructionist. Its form need no longer be solid or rectangular. It can expand into and pierce space; open space and light can enter into it. It need no longer be still but can move, linking space with time.

Such works can grow outwards by proportion, like a tree repeating its form, or a bridge arriving at a final and complete form. It follows that old systems or proportion cannot be used in the old way, so that proportion becomes functional again and becomes a vital developable thing, not a corrector, a rule to be obeyed, an academic principle or a beautifier, but capable of rendering precise ideas and of assisting in the development of new ideas.

from "An Art of Environment," Broadsheet No. 2. Privately printed, 1952.

We build our imagined entities on what we can perceive physically. The non picturable notions of the scientist are jumps or developments from the picturable. Conversely, these modern notions heighten our perception of the world in which we move. Having learnt of Brownian movement we see it with the naked eye in the movement of gnats. We are made more aware of our own position in space: clouds, trees, birds, rocks, flowers are occupants with us of this same space, each in their own temporal position.

For us architecture brings order to our space and a sense of architecture is a sense of ordered, enveloped and opened space in which we move and rest with pleasure or displeasure. It is not just a building; the interrelationship of house, town and country is also the concern of the architect. It is physical, made of materials, and acts upon us in a physical way. We are conscious of the heights and distances it employs and of their effect upon our senses.

A spiral staircase exists around a central pillar against which the steps are most nearly vertical and we feel acute physical awareness of the difficulty of attempting its ascent or descent at that place. But along the horizontal development of the steps is that place where we can move with the greatest regularity and ease, and it is there that we choose to go.

All streets, gardens, buildings, entrances, rooms, etcetera can produce different feelings in us as we move through them. The succession of these feelings can be organized to produce a totality of experience so that architecture can give us an ordered delight through its use of space, form and colour, as we rest and as we move, as we go about our everyday existence.

We are aware of the influence of modern art, particularly Cubism, on architecture. The Purism of Ozenfant and Le Corbusier was closely allied to Cubism and the painting of Mondrian and the work of the de Stijl group and Mies van der Rohe developed from it.

Mondrian, who sought and achieved equivalence in his paintings, placed round his walls rectangles and squares cut in different primary colours. The walls of his rooms both in Paris and New York were pitted with pin holes where he had changed the position of the cards or added another to their number as he sought for the satisfactory dynamic equilibrium. From his researches and achievements and from this movement out from the picture space into the space of architecture springs the notion of synthesis, whose pure form is an architecture created jointly by painter, sculptor and architect. In this there are no objects of art as such, no paintings on the wall, no sculpture on mantlepiece or pedestal which exist in their own right. But it is an architecture in which all three have pooled their resources to create—only architecture. And it seems to me that the artist, be he architect, painter or sculptor, might consider this notion and his position with regard to it.

from "Architecture, Machine and Mobile,"
Unpublished paper, 1955.

What is the function of a city sculpture? To appeal to and to express the multitude and/or the individual. In this project the artist was able to go in his own direction. There was no public demand for his work, no event or person to be celebrated or building to be decorated. There were limited resources. The artist could work from the tentative towards the concrete, from the confused towards something definite, to discover his own results which would include the participation of a site and people.

It was first necessary to find a sympathetic site. After exploration I found this place, by Arundel Gate and the Polytechnic, whose attributes I gradually came to realize. While it is within the city centre it is less crowded and less formal than the more obvious sites, also there is character to the movement around it. Traffic goes along the raised motorway beside it. Pedestrians come to and from the subway under the motorway or walk alongside it. People sit on the seats by the wall of the Polytechnic. A road and paths go down hill open to the south. For this place I have designed a work of art, a vertical progressive rhythm composed of a series of identical distances and a chosen variety of directions. The work is a column built with 19 identically shaped boxes (12 x 12 x 24 ins.) and 19 identical horizontal plates ($25^1/_2$ x $42^1/_2$ x $^5/_{16}$ ins.). The whole is approximately $19^1/_2$ feet high.

While it was being erected I was asked by an onlooker what it was. I said painted welded steel and then prompted by his look of dissatisfaction began to explain the work to him, to tell him that it was a permutation of an order of rotations. He could see the identical nature of the two elements used throughout. I tried to explain how the proportions of the plate were derived from those of the box which was a double cube. The alignment of the box with the plate above it was always the same and these formed the unit. Each unit was positioned on the one beneath in one of three directions diagonal and crosswise and it was these that had been permutated. I went on to say that as an invention it existed in its own right. It was a column constructed of rhythm thus having a correspondence with our own character and rhythm, and that we might appreciate the effect of its order and gain pleasure. It had been designed for the site, high enough to be seen from the road, its vertical progression set against the various levels and movements around it. Its blue painted facets took on the variety of the light and changed with it like everything around. It becomes a centre for the place and acts upon its character.

from "City Sculpture Project," STUDIO INTERNATIONAL, Summer 1972
[Peter Stuyvesant City Sculpture Project for Sheffield, 1972].

Teaching like art itself is dynamic. There must be an academic approach or it is not worthwhile being a teacher–or a student for that matter. But there must be a new academic, and it has got to be dynamic, not only throughout the student's course but in its very nature. We no longer have the same fixed tenets about the nature of man and the universe which were held in the last century. Certainty has disappeared. There is a philosophy of change and when we build our academic it needs to be a developing and changing one.

Of recent times in England we have been used to doing it all the student's way, the non-academic way. The student pleases himself and is patted on the back and told what a genius he is, or he is told that the blue is not the right colour or something like that. Earlier, and for centuries, the student had been taught anatomy, perspective, architecture, light and shade, the study of the antique–regardless of his personality. He was taught it so that the knowledge might be available to him in making a picture. It might be a Poussin or a David or "When did you last see your father?" but these practical things which had been learned were necessary. Today they are not necessary in the same way but to say there is no longer any need of anatomy, perspective and so on is wrong. The artists of this century have been developing a new sort of anatomy and perspective. It is not enough to destroy conventions, one has to build up something to replace them, something valid which can be used–and it is not a question of a formula for teaching but a form capable of extension and change. And it has not got to be separate from the rest of the work going on in the school as though merely an added subject. A basic course or a fundamental course or whatever it is called should go on right through the student's training because he continually needs fresh stimuli. He needs knowledge and he gets stimuli and knowledge through his own experimental work, his workshop studies. He is not sitting down to a lecture and just copying notes. For example, he is not just doing colour theory, he makes something with it. It is there for use, for comparison, and he finds that he is arriving at certain principles and he begins to be able to take risks. He sees potentialities in fundamental things which he can explore in diverse ways coming back all through his training to the laboratory and storehouse to find yet another possibility for development.

from "Teaching," a recorded statement, 1962.

## On Means and Content

The preoccupation of the abstract artist
Not with the power of what he does to imitate or allude to some other thing, but with the reality of the mark, object, sensation he is making.

A mark is made. What kind of force has it as it now exists? What power has it to be changed and what power can change it? What relationship can it play with other associated marks? What kind of interaction can take place?

Objects have an inherent power over us apart from all sentiment. (The still life painting is a manifestation of this.) The abstract, constructed work uses this power.

There are the large objects which are our environment. Buildings which we can walk around and enter. The constructed work of art can be as large as these. At any size it can be architectonic.

Awareness of sensation can vary from the acute to the subliminal and have an effect on the spirit. Environmental sensations (e.g. those of passing under or over). Sensations of light and darkness. Those caused by colour. Those caused by direction and change of direction. *These are both means and content.*

from "Means and Content (in abstract,
constructed work of art)," Unpublished paper, 1964.

Construction is method and end
Construction is not composition
Construction is primitive material built with
primitive law
Primitive law is natural forming law
Primitive material is the element which the
natural forming law develops into an appearance
An appearance which is not the result of this
is not a construction
In the process not only can the primitive material
be constructed but also the natural forming law
Certain false assumptions—
1  That construction must be three dimensional
A pencil line or a coloured area are primitive
material. These are one dimensional—so to
speak—or two dimensional
2  That construction should be orthogonal
If the primitive material of an angle is
developed by the natural forming law of
oscillation a series of angles may ensue
none of which need be a right angle
3  That construction should use new material
A length of wood can be a primitive material
constructionally

from a letter to a fellow artist
24 September 1961.

A construction can be of any material with which it is possible to do that operation and can be in any possible dimension. Material and dimension (choice and development) are governed by the practical and the aesthetic.

Being the opposite of abstraction, construction begins in the most primitive manner, but it is dangerous for the artist to fall in love with primitivism. The elementary methods of construction are related to the elements of life, the forces of life. An example can be a band ornament drawn in line on the plane, which can be simple, subtle and dramatic, which can be directly related to life in its modulations and inevitability. Life is variable and inevitable, recurrent and developable. For the individual it is essentially tragic.

Or to re-start rather differently. An event or a series of events may be ordered by a rhythm. The same event can be repeated varying its temporal or spatial position. An event can be inverted and take on a new, strange character. A whole system can be changed by inversions. Events and systems of events considered plastically with equivalence between tangible and intangible elements can become an expressive structure. Events are changed or rhythmically related by means of kinetics. The primitive forces of kinetics are universal, they are within us and without. Therefore through their use it is possible to express life. However construction must start with the simplest and most practical means and to avoid confusion aim at the simplest results. The method is empirical and moves from ignorance to knowledge.

The spiral, the crystalline and the amorphous are primary attributes of nature used by artists from remote times to the present to express their position in and attitude towards the universe. They saw and felt the spiral, used it to express what they saw and felt, to comprehend and to feel more and to express what was beyond comprehension. The spiral expresses dynamic and aspirational forces. The crystal has the very refinement of order from which deviations are errors. In drawings by Leonardo, rocks are crystals disrupted by spiral forces.

The work of art can be a crystal formation on the plane. In a painting the canvas can seem to be such a formation, transparent, through which the perspective of a scene passes. The formation is distorted and the facets shift. And so, as in many Seurats, the work is in this sense a sum of deviations from the crystalline.

In paintings (Titian, Tintoretto, Degas, Cézanne, etc.) the spiral and the crystalline have been fused together in many ways. The writer Jay Hambidge posed a solution for the complete fusion of spiral and crystalline on the plane in his books on "Dynamic symmetry."

The amorphous is ambiguity, the first transition from the void towards form or the last after disintegration. Art corresponds with man's attitude towards nature and with the feelings of life within himself.

My work is kinetic whether the result is still or moving, therefore I am concerned with change—and with chance (which also has strict laws). If life is essentially tragic then I cannot believe in Utopia no matter how I strive for perfection. It is interesting to note here that in a society of geometric figures ("Flatland" by E.A. Abbott) the circle is a being of far higher order than a square. It is possible for a square through hereditary change, the adding of an angle each generation, to ascend the social scale towards a state of anglelessness. A moving towards perfection of asymtotic character, attaining only the semblance of it. For me each figure has its intrinsic character to be studied and used and change and character is in itself a dynamic event which can be more important than the character.

For me the form is the result of the events. I work with these and become engrossed in them. The end product becomes then a matter for consideration as to what these events have achieved and then I must re-order them again towards what is for me the new.

The artist constructs with forces and the results of forces. He, himself, is a bundle of forces as in his work. Sometimes the work is the product of a slow direction (monotony is a powerful force), or it is busy with change and seeming instability (Picasso's sum of destructions).

The work of art holds opposites within itself, horizontal against vertical, acute angle against straight, open against closed and so on. Then there is the opposition against the norm within the work. In the purely orthogonal work the deviation from a regular partitioning is expressive (Mondrian), while in cubist works expression is achieved by shifts from the vertical and horizontal. If the latter can become too confused the former can be too static.

The artist limits himself by the means with which he works, the choice is part of his subjective nature. The norm, the powerful monotony, becomes an episode or a field which he develops, changes or interrupts through the use of slight changes or direct oppositions.

from an unpublished draft for "Contruction from Within," STRUCTURE 6-1, Amsterdam, 1964.

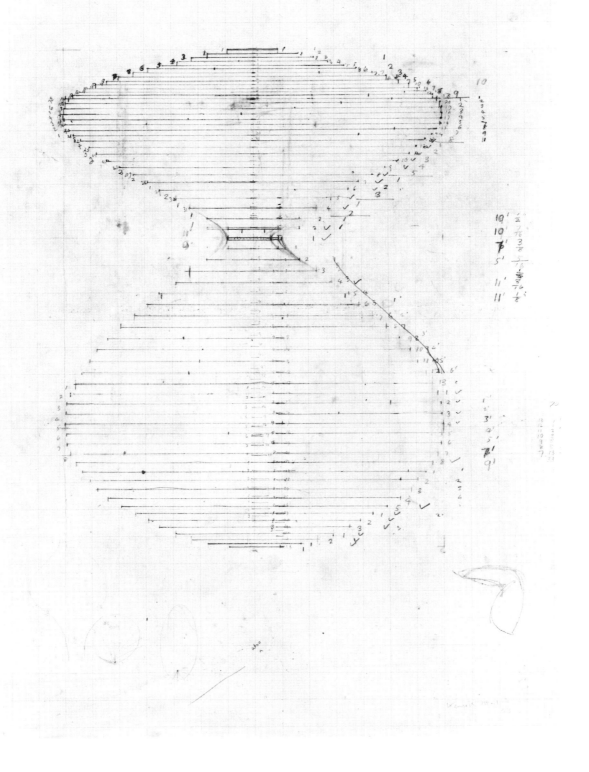

**1**
**Drawing for Screw Mobile** 1953

## Screw Mobiles

The works in this group are crucial to the rest of Martin's oeuvre. With them the central themes in his work make their first concerted appearance. The forming role of movement comes into its own, and with it the fusion of painting and sculpture. A point becomes a line through movement, a line a plane, a plane a volume. Each work is concerned with at least two types of movement, its actual movement in rotation, and the virtual movement of its spiral configuration around the central axis, to which the various features of its construction all contribute: angle of incidence of each horizontal, and the shifting lengths and widths of each. Every one of these factors is subject to control and development. Further types of movement are developed later by the introduction of secondary elements either in the plane of the radius or the tangent of the primary rotation.

The procedure by which an early mobile evolved has been described in detail by Michael Compton. The drawing he is discussing is no. 1 in the present exhibition.

Kenneth Martin drew a circle of 7″ diameter and, taking a point on the circumference, drew 35 lines at successive intervals of 5° from the tangent. (A small rough sketch of this system appears near the lower left corner of the drawing.) The lengths of 33 of these lines (omitting the two shortest), twice repeated in the same order, comprise the parallel horizontal lines in the large figure. Each line is repeated to left and right of the central axis to form a mirror symmetry.

The interval between the lines is varied according to the widths of stock brass sections, from $1/8$″ to $1/2$″ at $1/16$″ intervals. The number of times each width occurs is determined by the Fibonacci series: 1 1 2 3 5 8 13, reading from the bottom. The order of widths is reversed between the bottom and top segments of the drawing so that the lower half comprises 1 at $1/8$″, 1 at $3/16$″, 2 at $1/4$″, 3 at $5/16$″, etc. up to 13 at $1/2$″, while the top half comprises the series 1 at $1/2$″, etc. up to 13 at $1/8$″.

Brass bars $1/16$″ thick were cut to correspond in width and length with these dimensions, together with an additional bar of width $9/16$″ and length equal to the omitted shortest lines. This dimension can be seen on the drawing as two marks on the line immediately above the narrowest part of the drawing and the bar was inserted between the two sequences so that there are 67 bars in all.[9]

A.F.

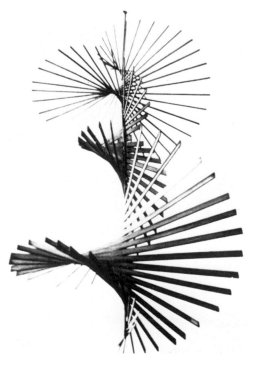

**2**
**Screw Mobile** 1953

[9] Michael Compton, KENNETH MARTIN, Vol. II, Tate Gallery, London, 1975, p. 25.

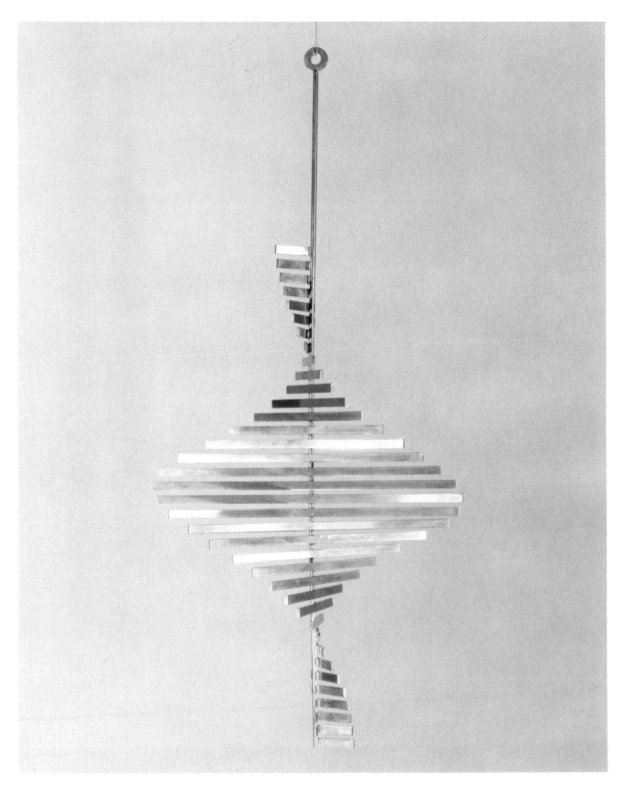

**3**
**Screw Mobile** 1953-73

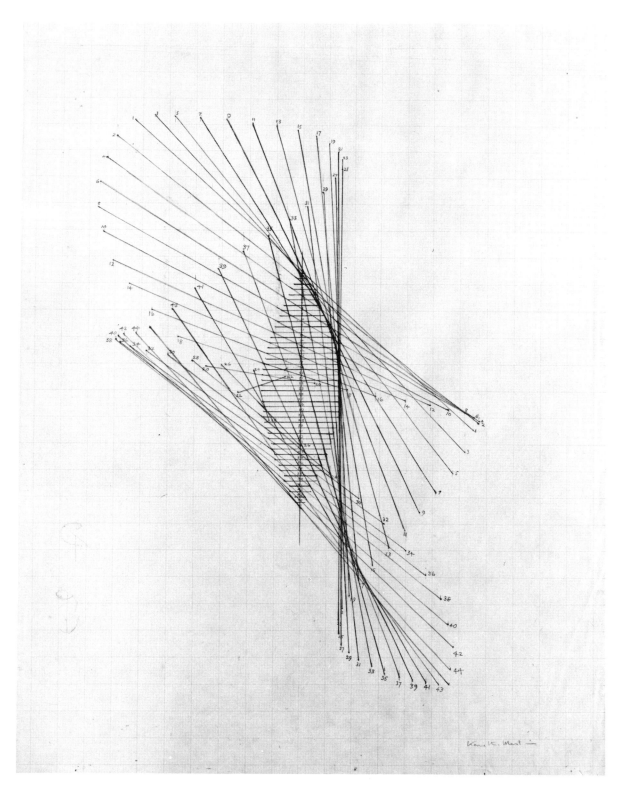

**4**
**Drawing for Screw Mobile** 1955

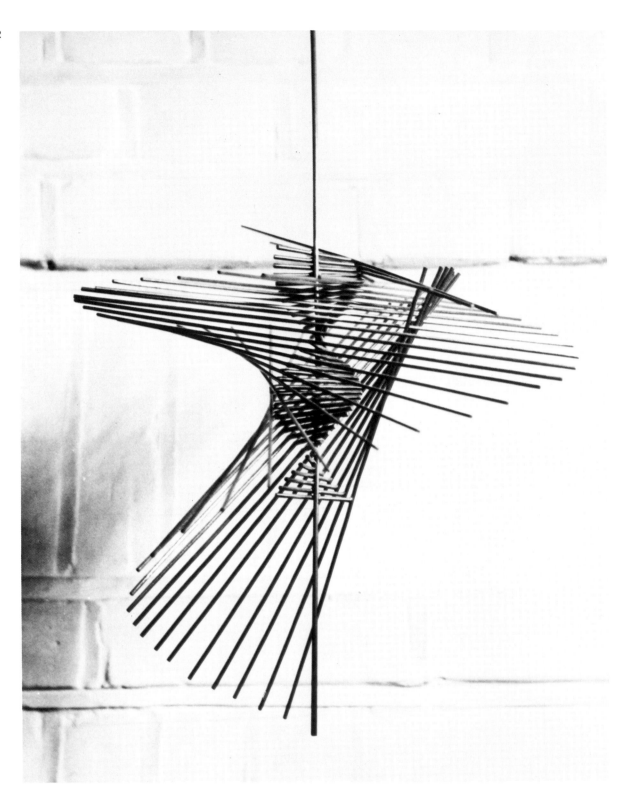

**5**
**Screw Mobile** 1955

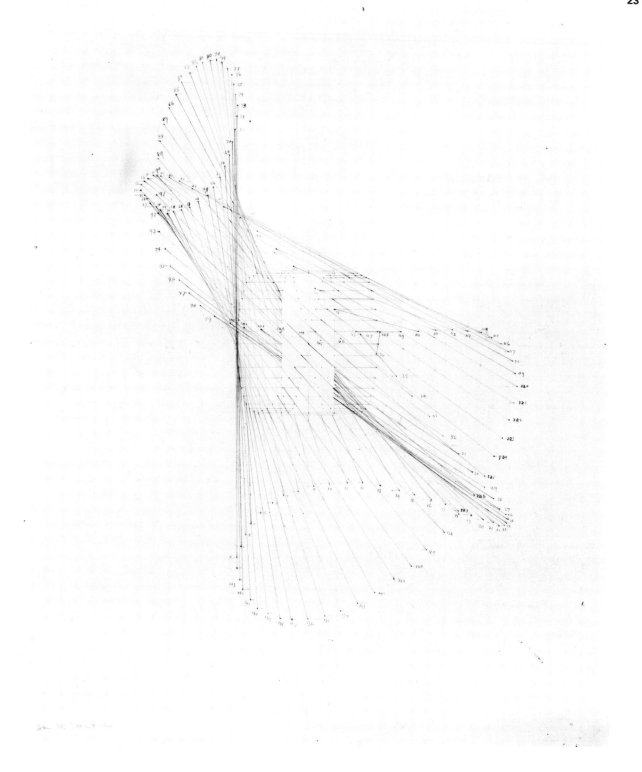

**6**
**Drawing for Screw Mobile With Cylinder** 1956

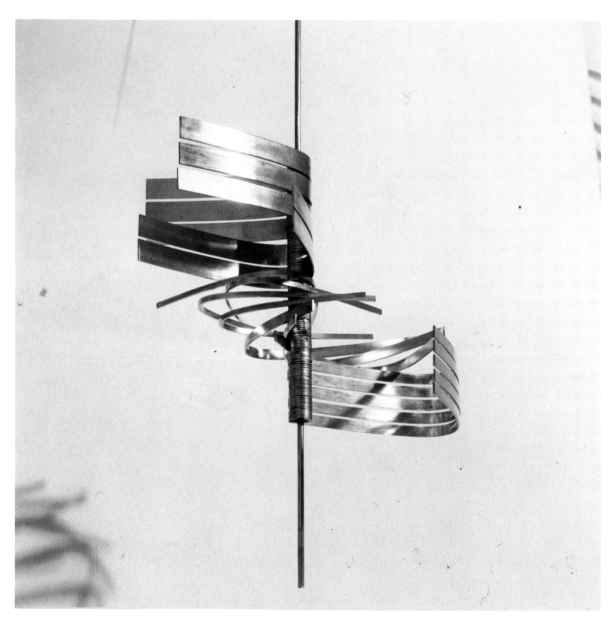

**7**
**Small Screw Mobile** (3rd version) 1965

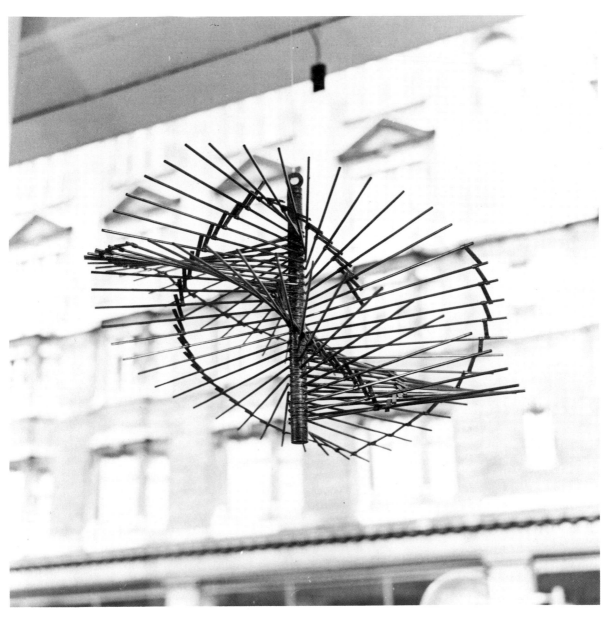

**8**
**Screw Mobile** 1966

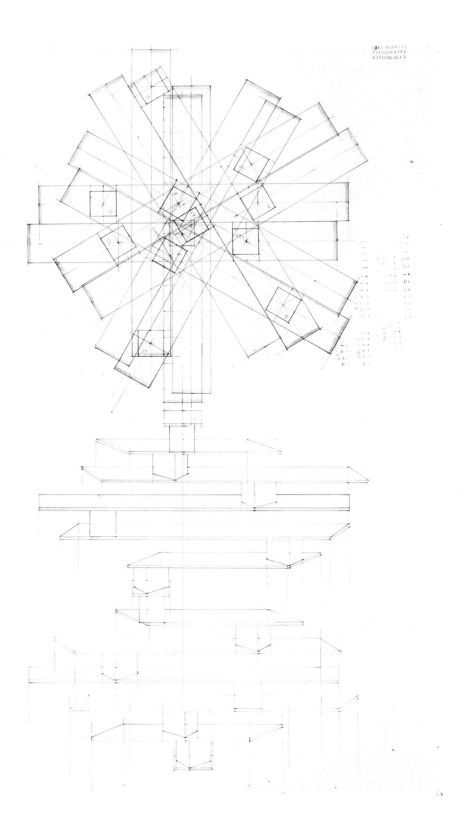

**9**
**Drawing for Screw Mobile** 1968

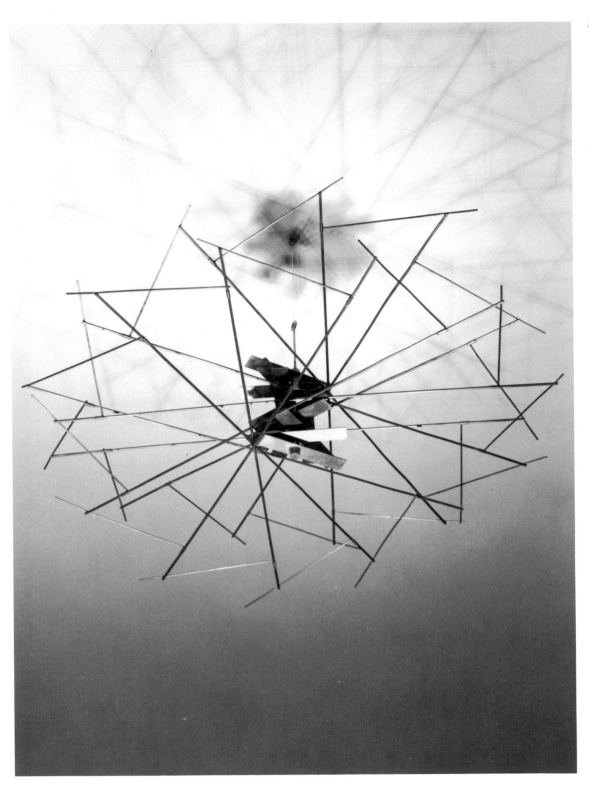

**10**
**Screw Mobile** 1968

These are drawings in space. As in so many of Martin's works, we can trace a line as a path through space and follow it through a series of rhythmic developments. We can also see these works as volumes growing out of the harmonic relationships of a family of triangles. The two ways of reading them interact, one giving way to another but also being informed by the other.

The dimensions of the triangles are determined by Kenneth Martin's play with the spiral form, expressed in numerical series; for example a series in which the ratio between each number is 1:2 (.5, .7, 1.0, 1.4, etc.) or the Fibonacci series (2, 3, 5, 8, etc). A drawing is made setting out a development of triangles whose dimensions derive from such a series. Lengths of 1/8" square section bronze strips are measured off on these drawings and made into a continuous three dimensional triangulation. In the course of this development the artist explores various ways of joining the triangles: side to side, tip to tip, fanwise along an axis. In some of the LINEAR CONSTRUCTION particular triangles will be given special emphasis by building up further strips; in others the linear "path" will be emphasized.

A.F.

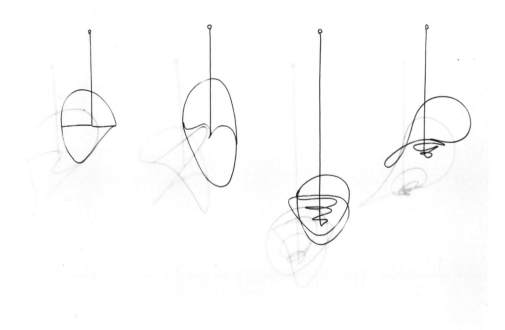

**11**
**Four Lines in Space** 1959

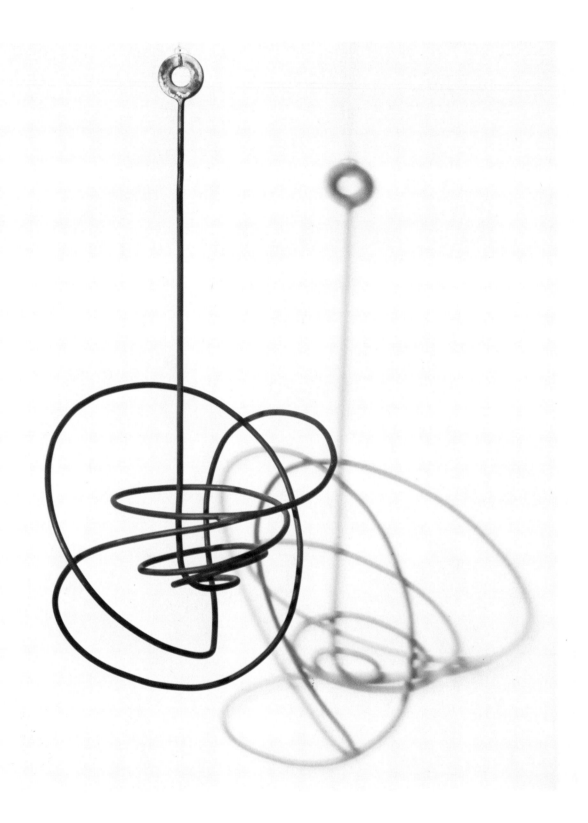

**12**
**Line in Space 1** 1960

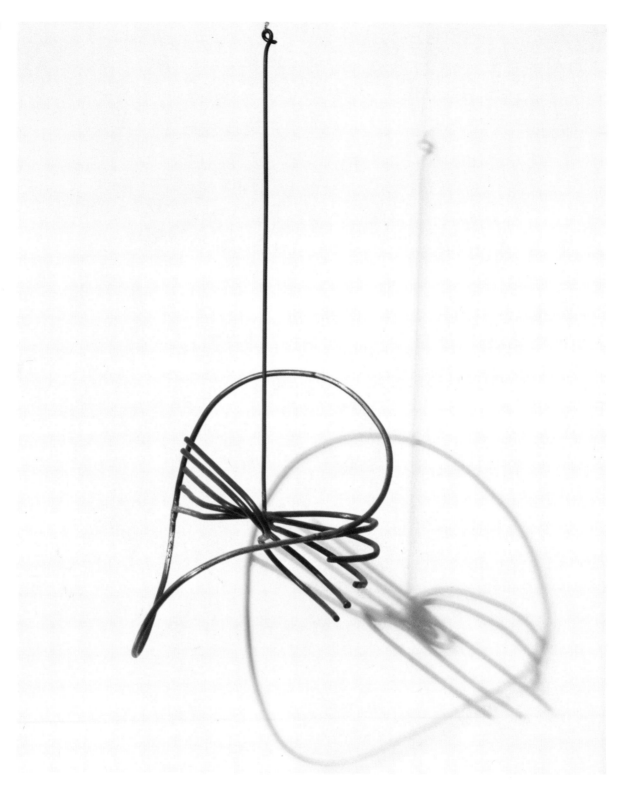

**13**
**Line in Space 2** 1960

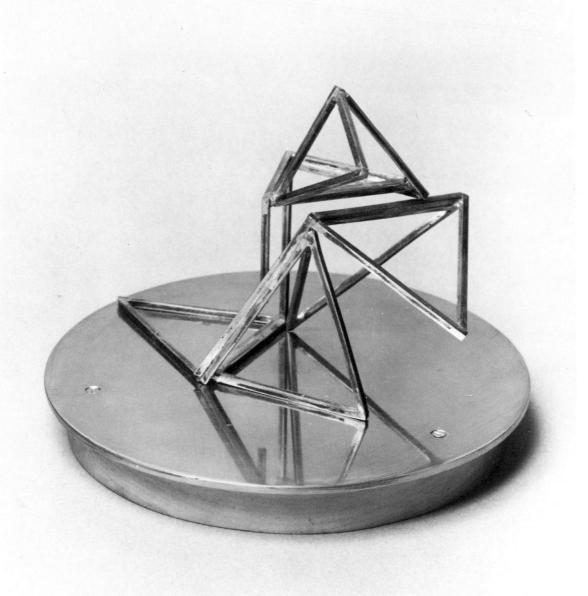

**14**
**Linear Construction** 1961

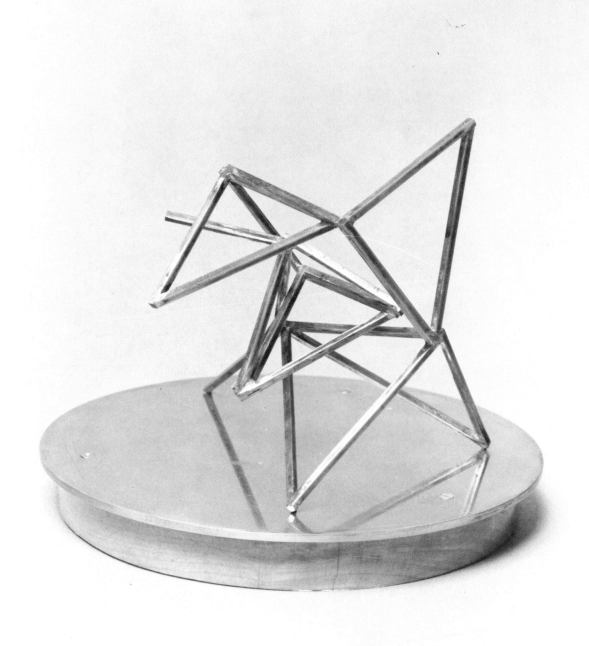

**15**
**Linear Construction** 1961

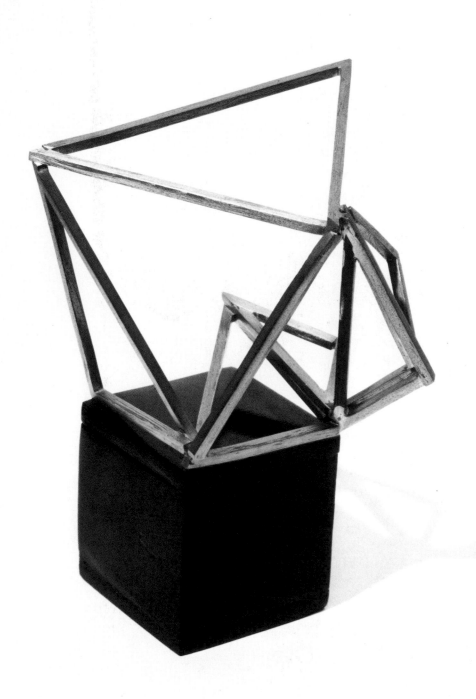

**16**
**Line With Black Box** 1961

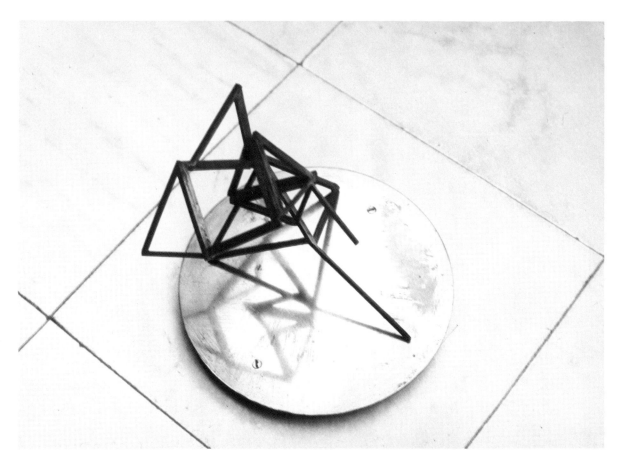

**17**
**Linear Construction** 1962

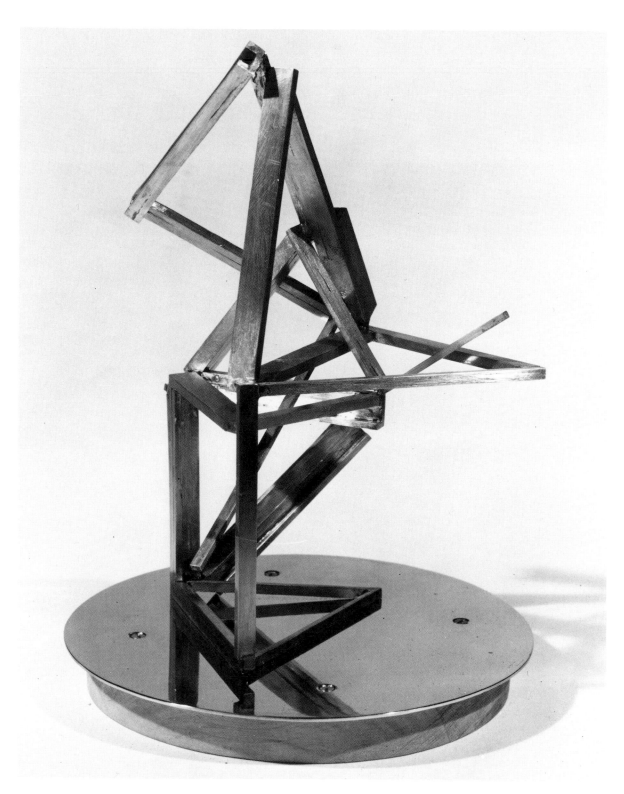

**18**
**Linear Construction** 1964

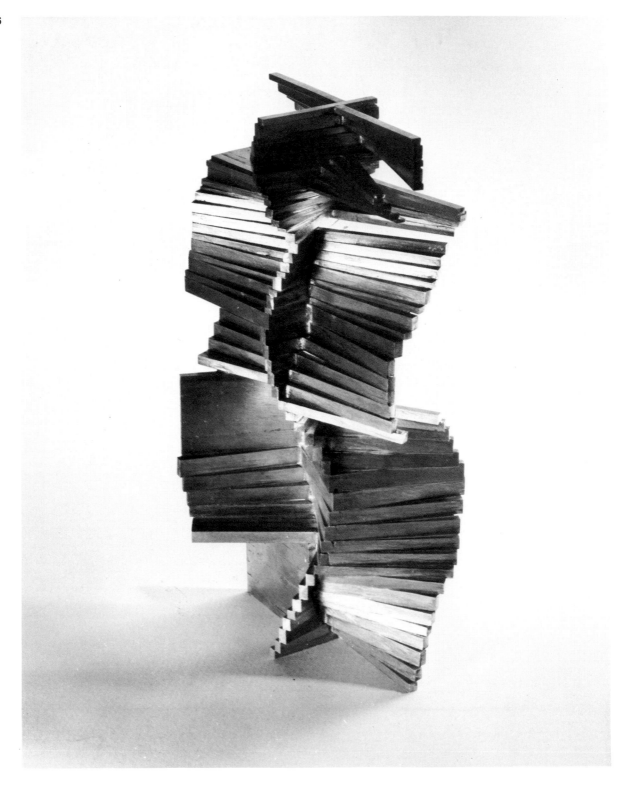

**19**
**Oscillation** 1963

## Oscillations

These are towers made up of units of square-section brass tube joined one to another. In most works in this group the units consist of a central bar and two lateral bars, one on each side, at right angles to it. Each central bar is thought of as having a fixed number of "stations" along each side of its length. The development of the piece results from shifts in the position of the lateral bars from station to station along the central one; and of shifts of the central bar in relation to the one below it. These shifts are irregular, or syncopated, and they are calculated according to a system worked out on a chart in which positions are permutated rhythmically, with repetitions, rests, inversions, and cross-rhythms. These calculations are subject to certain further rules imposed by the practical need to join the pieces together firmly.

Kenneth Martin has written about these works:

In all my groups of works the first ones I make are empirical. Then these can suggest more rigorous processes. For instance the OSCILLATIONS started from works with a rhythm of a jazz-like nature which developed as the work progressed. From these they became programmed works as I began to understand and develop the nature of the content. A programme was invented from the experience gained which went up one side of the centre of the construction and down the other, fusing them together in a union of complementaries and oppositions. So that the height of the work as well as the width had a natural limitation. The programme was based on the material and the methods of construction.[10]

A.F.

[10] Kenneth Martin, "Chance and Order," ONE, London, October 1973. Republished, KENNETH MARTIN, Vol. I, Tate Gallery, London, 1975, p. 45.

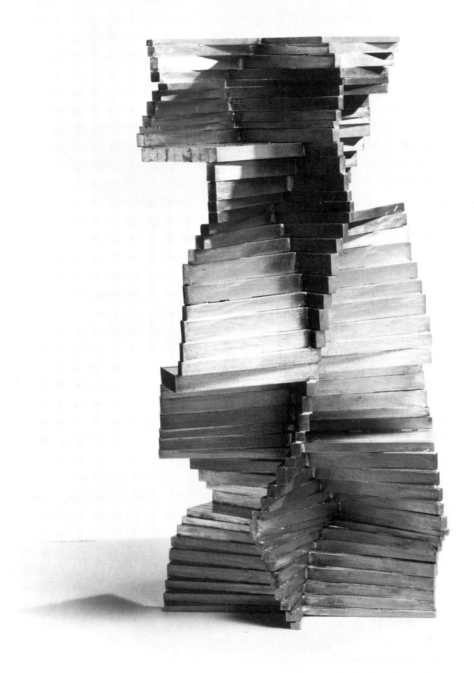

**20**
**Oscillation** 1963

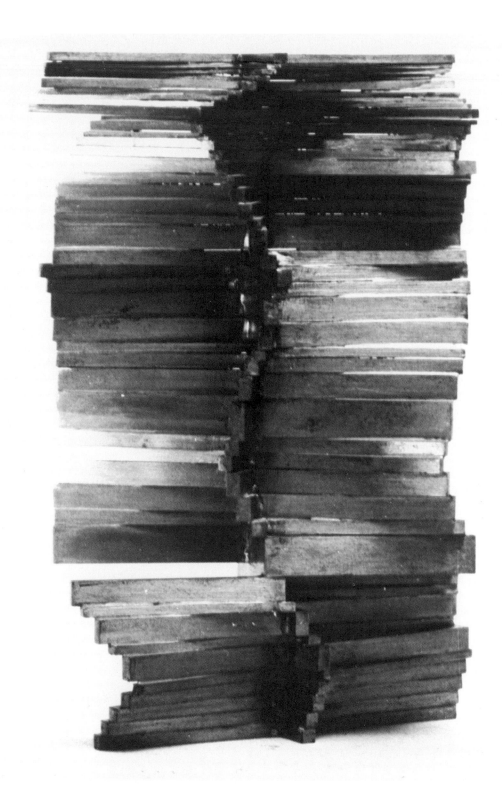

**21**
**Oscillation** 1963

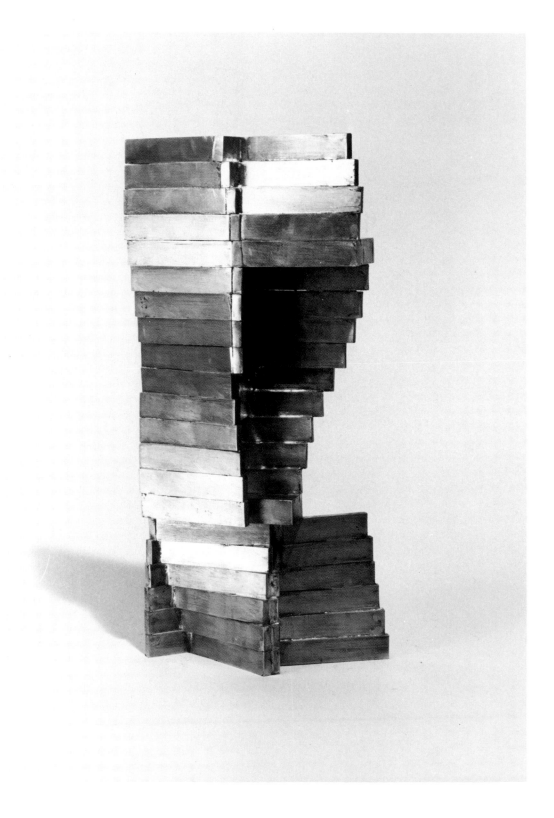

**22**
**Oscillation 'A'** 1964

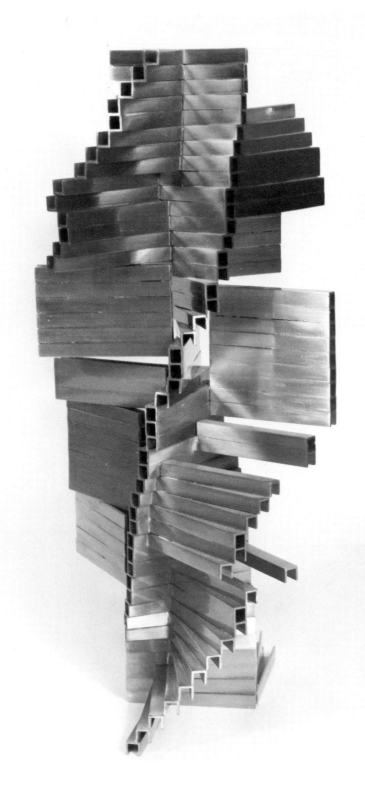

**23**
**Oscillation** 1973

These groups of hanging or standing construction are among the most complex of Kenneth Martin's work in three dimensions. In the different versions of TUNNELS IN THE AIR, cylinders made up of brass washers were attached to lengths of square-section brass tube in progressive stages. The conjunction of cylinder and straight unit relates these works to the spiral mobiles. The cylinder can be thought of as a displaced axis which "rolls" along the bar and is stopped at various predetermined stations. In the TRANSFORMABLES, the cylinders become hinges, giving a limited range of movement to the straight units, and hence opening up a world of indeterminate relations between the parts.

These works remind us of Kenneth Martin's phrase, "an architecture in epitome." The eye is invited to explore ramps, paths, see-saws, openings and closures, inside and out. The slow turning of the TUNNEL IN THE AIR pieces gives a sense of movement not unlike the sensation of being in a slowly moving vehicle; and against this, the arrested "movement" of the rolling cylinders plays as a counter theme. The invitation here to enter the work and explore it intimately relates to Kenneth Martin's preoccupation with what he calls primitive or fundamental form. We categorize and make families of certain forms which we are continually experiencing in different contexts in life: the spiral is one, the cup, the ball, the box, the tunnel are others. Our experience of each example has a resonance which it owes to all our experiences within that family of form and it is this which allows the artist to claim universality for his forms.

A.F.

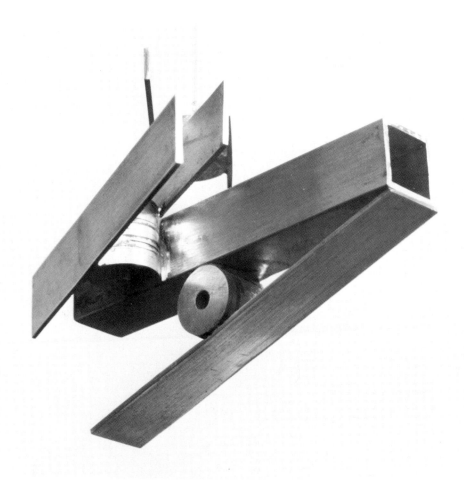

**24**
**Tunnel in the Air** (1st version) 1965

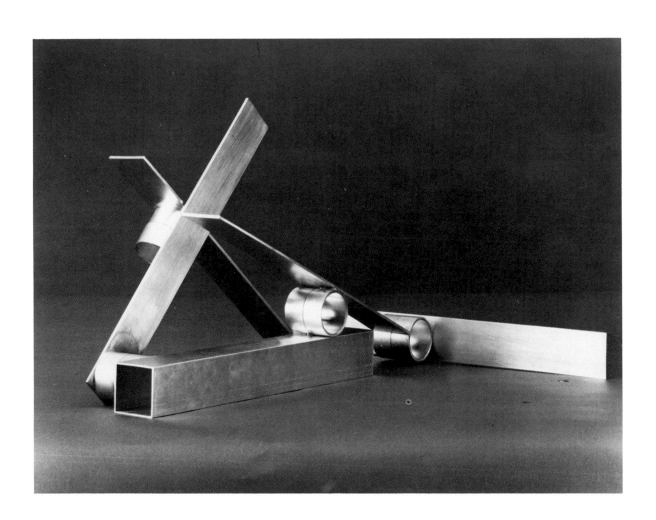

**25**
**Transformable** (2nd version) 1966

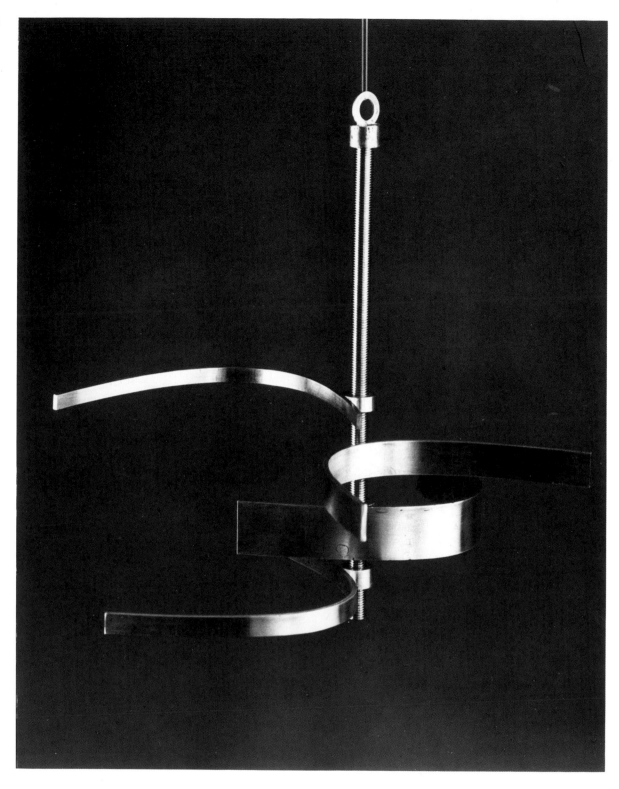

**26**
**Variable Screw** 1967

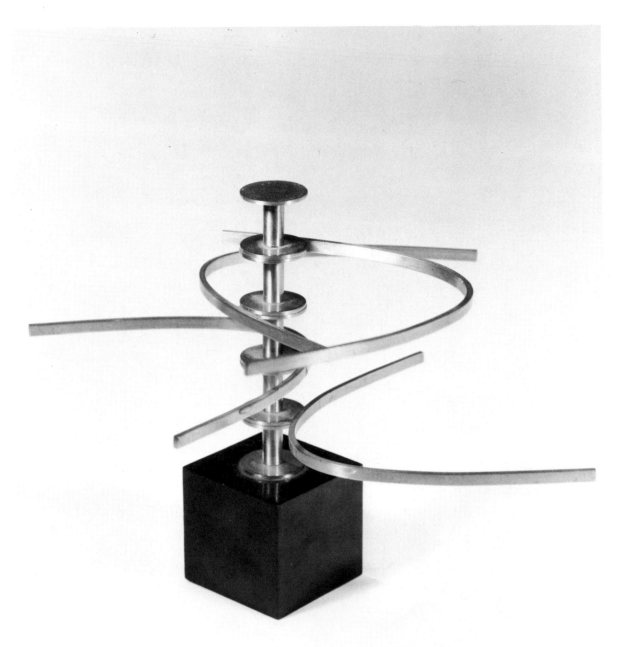

**27**
**Variable** (Documenta Multiple) 1968

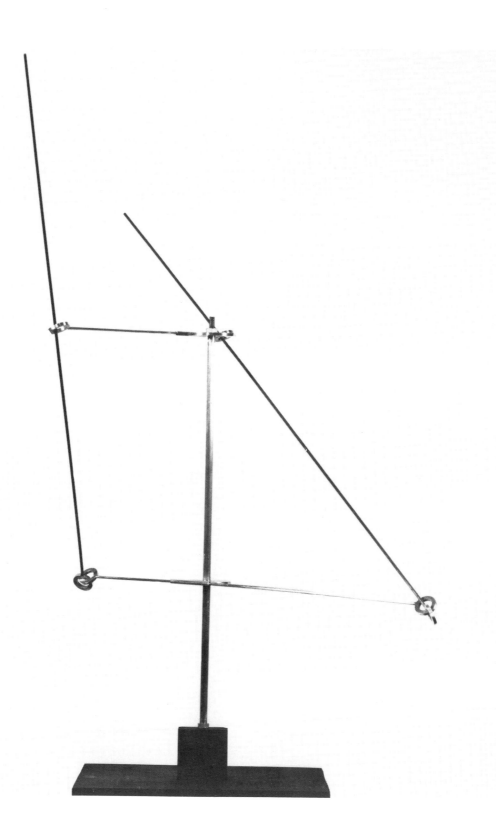

**28**
**Standing Linkage** 1970

## Rotary Rings

Works in this group are made up of parts which are screwed onto a threaded axis and freely adjusted. The orientation of each part and the interval between one and the next is open to a great range of variety, subject only to the requirement that the piece should balance and hang vertically.

The moveable parts consist of groups of brass rings and bars of various sizes brazed together into horizontal clusters. The rings are of predetermined diameters and widths, their proportions constituting a series. The make-up of each cluster is determined by a system of permutations which gives the combination of diameter and width of each ring, the length of each bar and the sequence of all the parts. Each cluster corresponds to a row of permutated symbols.

With these givens in hand, Kenneth Martin composed each cluster freely and empirically. There is thus an interplay between the determined and the free which extends from the make-up of each part to the final adjustment of the work as a whole.

When these works are turned by hand, they reveal a whole range of movements and apparent changes of speed. Illusion enters the work and some parts appear to turn independently of each other; others, not to turn at all. Reflected lights play an important role, running around the rings forward or backward and even stopping, so that accelerations, decelerations, and pauses have a place within the actual turning speed.

A.F.

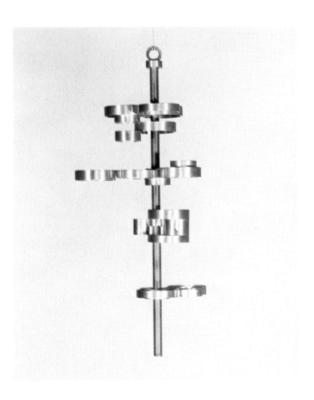

**29**
**Rotary Rings** (1st version) 1967

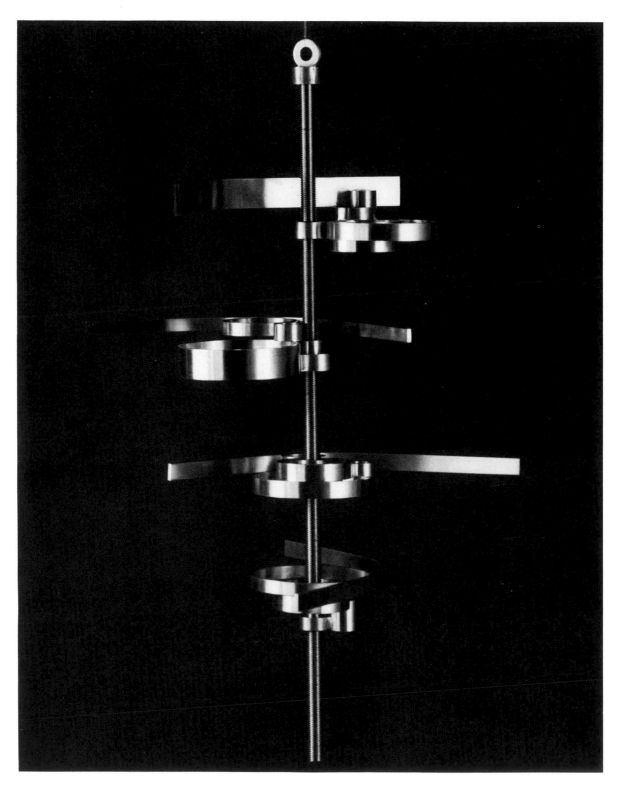

**30**
**Rotary Rings** (2nd version) 1967

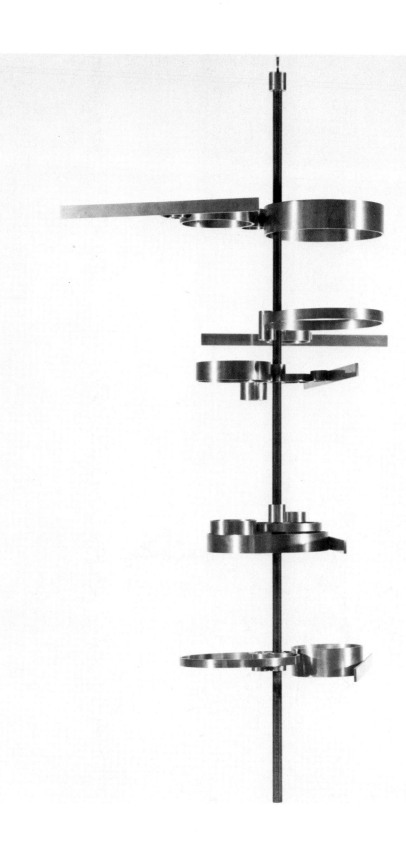

**31**
**Rotary Rings** (3rd version) 1967

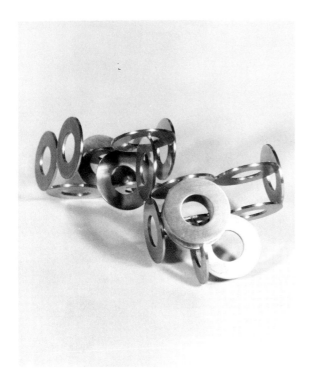

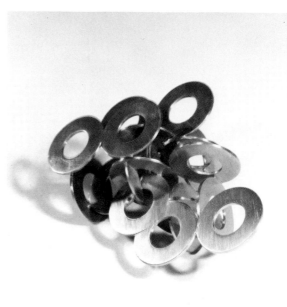

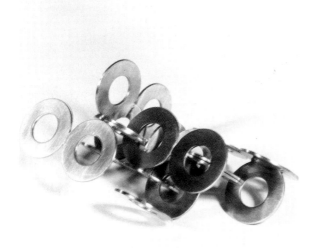

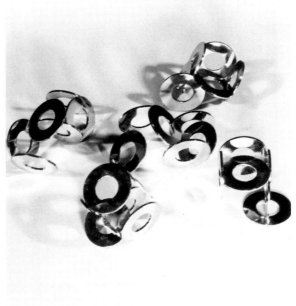

**32**
**Chain System** (2nd version) 1968-69
**33**
 **Chain System** (3rd version) 1968-69

**34**
**Chain System** (4th version) 1968-69
**35**
**Five Times Five** 1970

## Chain Systems

The theme of this group is the possible ways in which a washer can be joined to another washer in the same plane or at 90 degrees to that plane. Kenneth Martin categorized these ways as follows:

A. Edge to edge like two coins touching on a table top.

B. Edge to edge as in A, but with one washer standing vertically.

C. As in B, but with the standing washer in the plane of the diameter of the lying washer.

D. As in C, but with the standing washer located in the center of the lying one.

E. Edge to edge in line as in A, except that the plane of one washer is twisted 90 degrees.

F. A further relationship with the two washers face to face is met with as a consequence of other ways of joining.

These letters designating these different joins are permutated giving a formative rule to each piece. For example, in the work called FIVE TIMES FIVE Kenneth Martin took the three joins which place the washers at right angles to each other, B, C, and D and permutated them as follows:

1. B C D C B
2. C C B D B
3. C D B B C
4. D B C B C
5. B B C C D

The piece comprises five elements, each with six washers and five joins. Each join is diametrically opposite the previous one except when it is of type D when the new washer is placed on the diameter itself.

A.F.

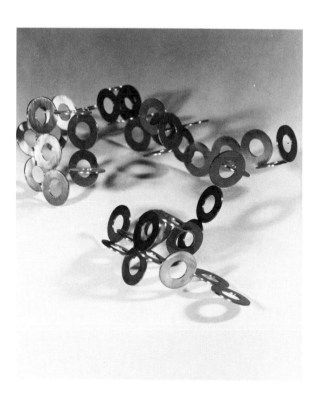

**36**
**Broken Chain** 1968-70

The long series of drawings, paintings, and prints in this group have evolved from studies which Kenneth Martin began in 1969. These were drawings on graph paper in which a square grid was marked out and the points of intersection numbered. There might be, for example, five rows with five points in each row. The numbers one to twenty-five would be written on slips of paper which were then picked at random, the resulting sequence of numbers being written down in two columns. These columns become the instructions for the drawing, each pair of numbers giving a line from one numbered point on the grid to another. Chance thus determines the length and orientation of each line and the total configuration as it emerges within the fixed framework of the grid.

The procedure, which is described here in its simplest form, soon becomes subject to development and elaboration. Viewed as process, each line has a direction given by the pair of numbers which generated it. *From* point 14 *to* point 9 and so on. By shading consistently on one side of the lines according to this direction, Martin could enrich the image according to its kinetic development. This soon developed further by turning the single lines into strips and by multiplying the strips according to the order in which they are drawn, the first line becoming a single strip, the second two parallel strips, the third three, and so on. This in turn gives the choice of passing the strips either over or under the strips that were already in the drawing, thus building a spatial structure from a process extended in time.

Chance guarantees a seemingly endless succession of combinations. The framework within which it is allowed to operate is precise in all its terms. The combination of randomness and definite rules leaves the artist free to invent in an exact sense. Each feature of the "game" is subject to control and adjustment. Naturally the smallest change can result in a radically different drawing. The grid itself can be subjected to simple changes, tilted from a square to a lozenge, or constructed from circles within squares, giving a more complex interval between the terminal points. Each grid can be numbered in different ways. The introduction of color is the occasion for further extensions of the rhythms.

Allied with the CHANCE AND ORDER drawings but distinct from them are the various series of METAMORPHOSES drawings, in which the linear movements across the grid are determined by permutation. In these he plays out all the variations of order in a given sequence of numbers and, by returning the completed permutation to its starting point, gives a closed character to the movement of the drawing.

With all these works there is a double invitation: to explore the drawings as statements about an inventive process; and to contemplate the products that are generated by that process. The paintings represent such products; they occur when a configuration having particular force and vitality is set aside from the process and given a richer embodiment.

A.F.

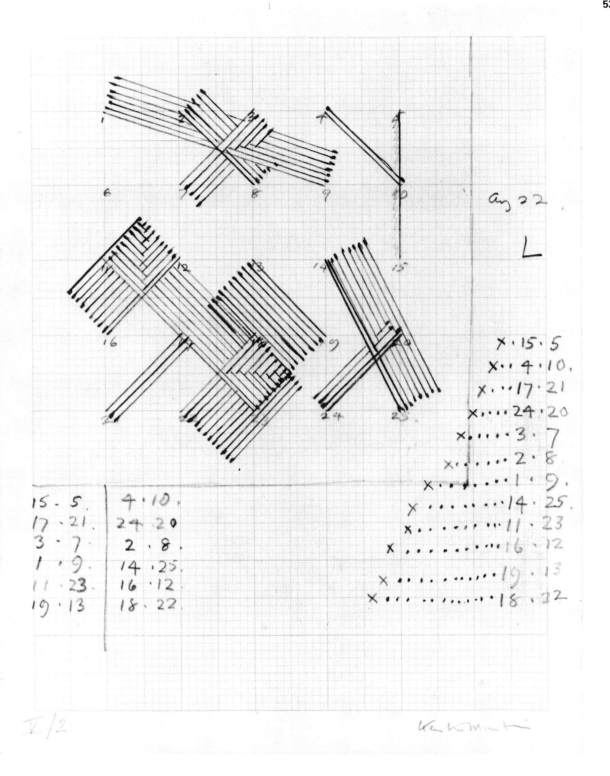

ang 22

L

X · 15 · 5
X · · 4 · 10 ·
X · · · 17 · 21
X · · · · 24 · 20
X · · · · · 3 · 7
X · · · · · · 2 · 8 ·
X · · · · · · · 1 · 9 ·
X · · · · · · · · 14 · 25 ·
X · · · · · · · · · 11 · 23
X · · · · · · · · · · 16 · 12
X · · · · · · · · · · · 19 · 13
X · · · · · · · · · · · · 18 · 22

| | |
|---|---|
| 15 · 5 · | 4 · 10 · |
| 17 · 21 · | 24 · 20 |
| 3 · 7 · | 2 · 8 · |
| 1 · 9 · | 14 · 25 · |
| 11 · 23 · | 16 · 12 |
| 19 · 13 | 18 · 22 |

V/2

Kenneth Martin

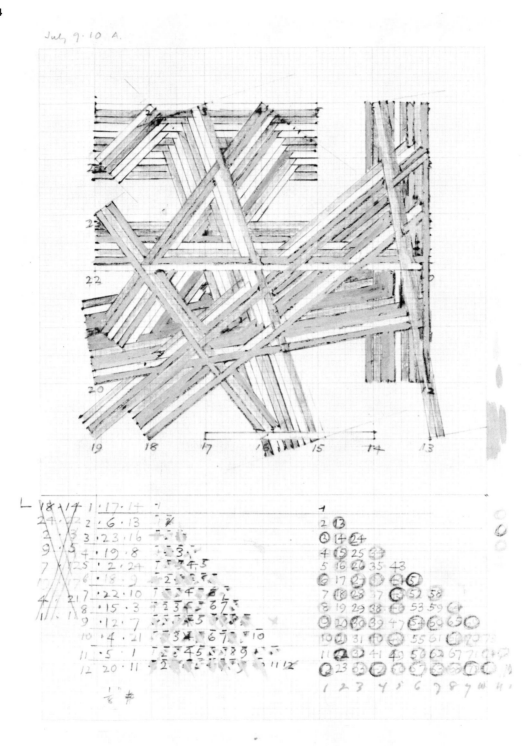

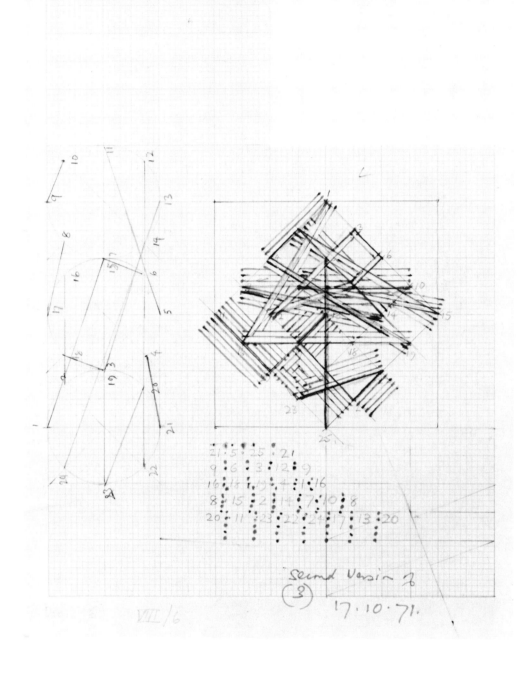

**39**
**Chance and Order VIII/6** (circa 1969-72)

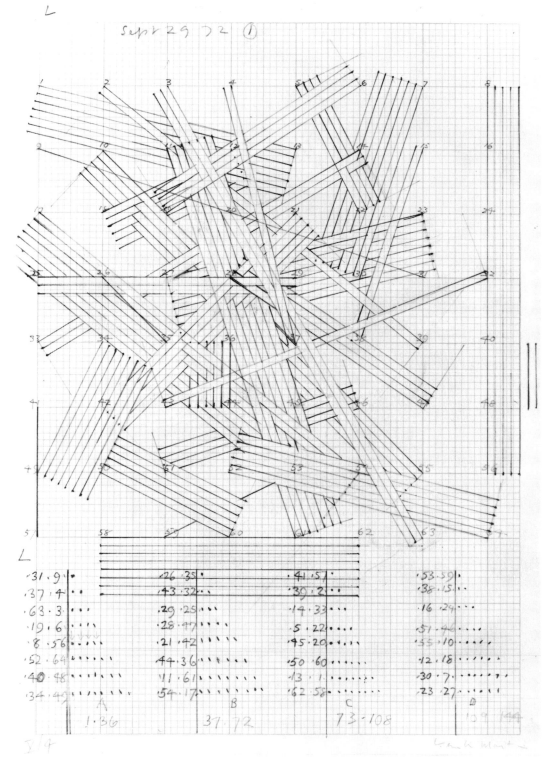

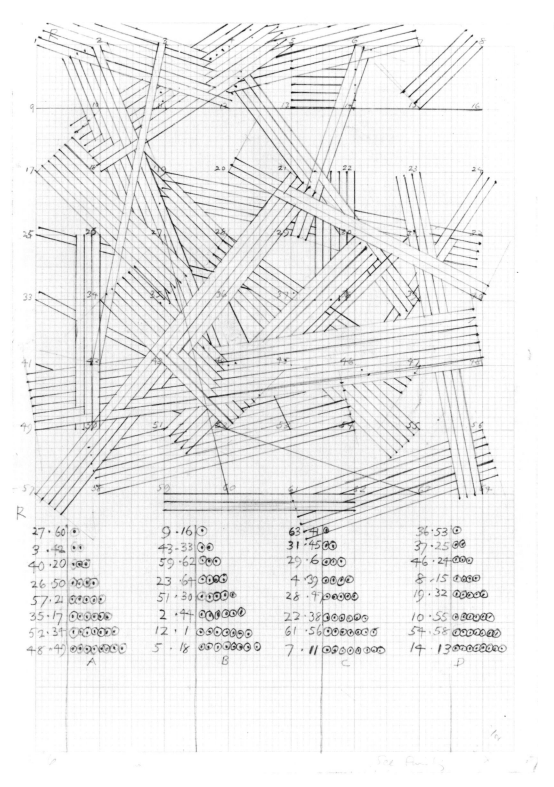

**41**
**Chance and Order X/6** (circa 1969-72)

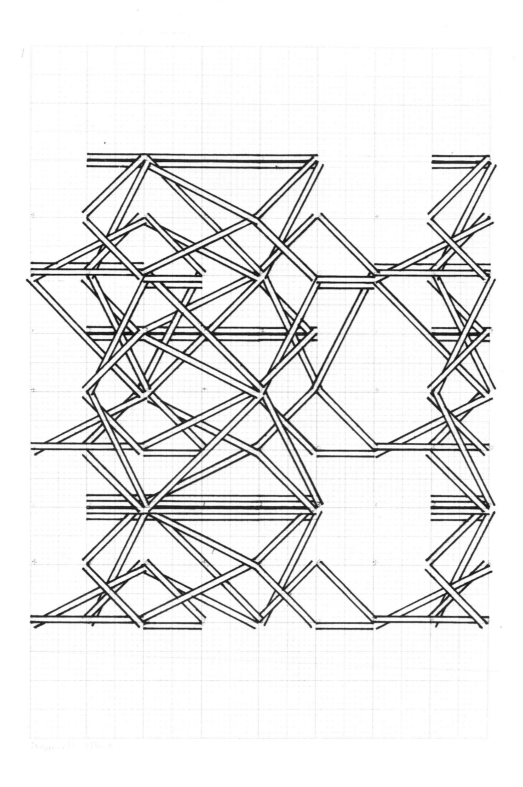

**42**
**Sequence of 9 Chance and Order Drawings** 1974

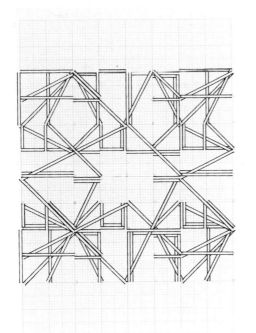

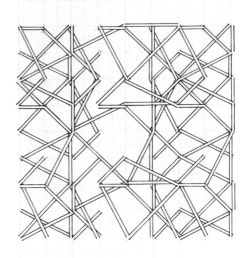

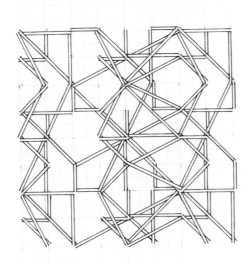

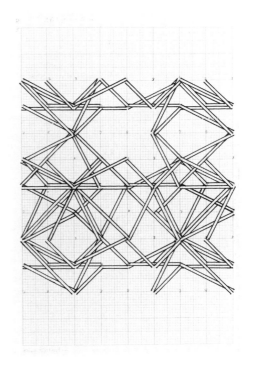

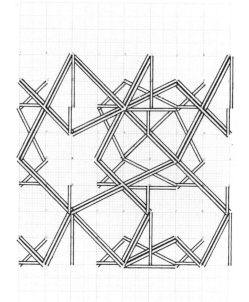

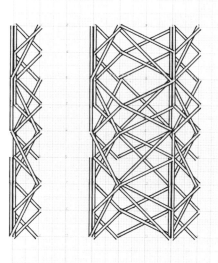

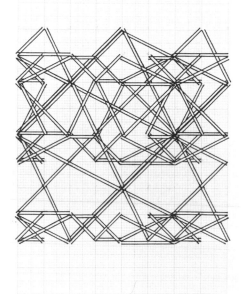

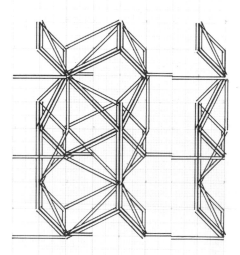

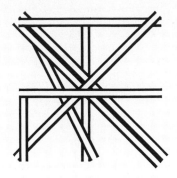

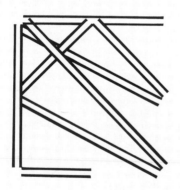

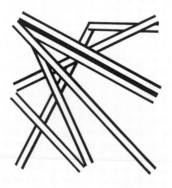

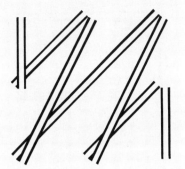

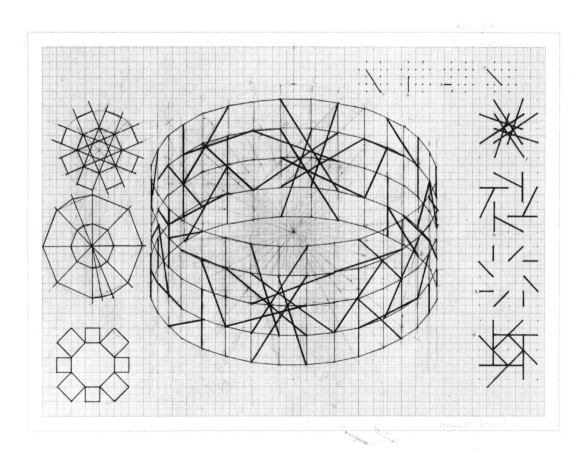

**44**
**Series of 22 Drawings** 1976
**No. 20**

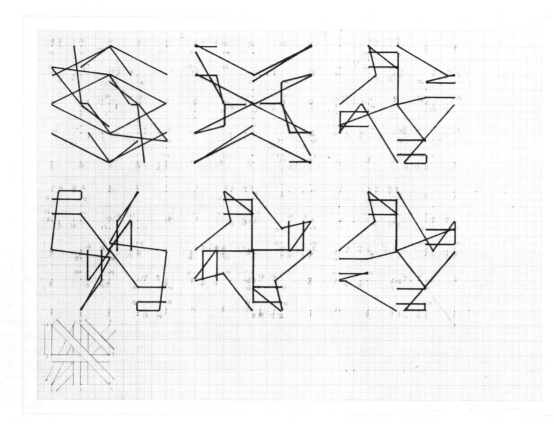

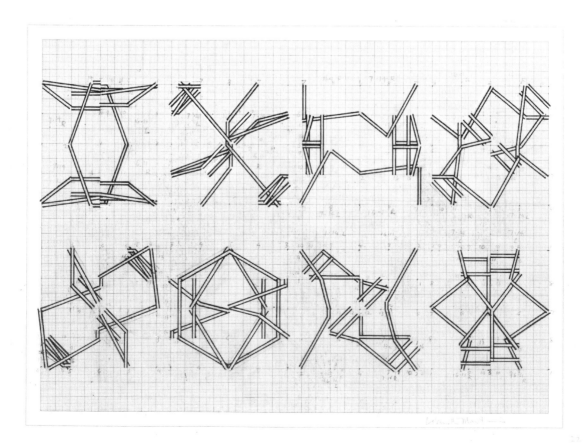

**22 Drawings** 1976
No. 13
No. 22

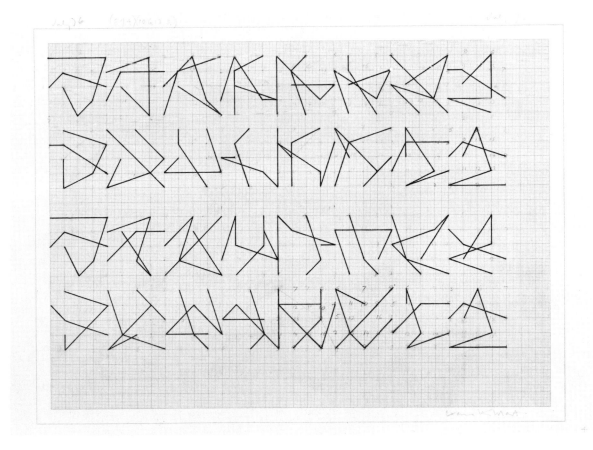

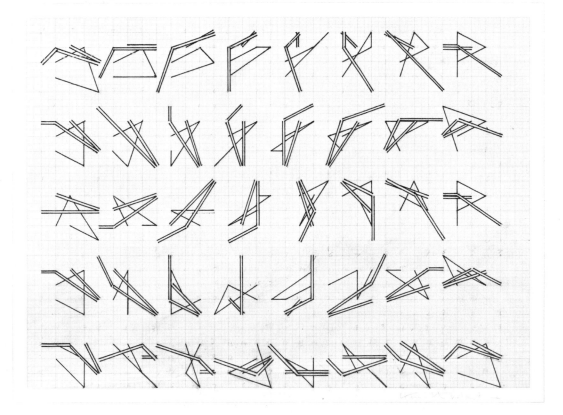

**22 Drawings** 1976

No. 4

No. 5

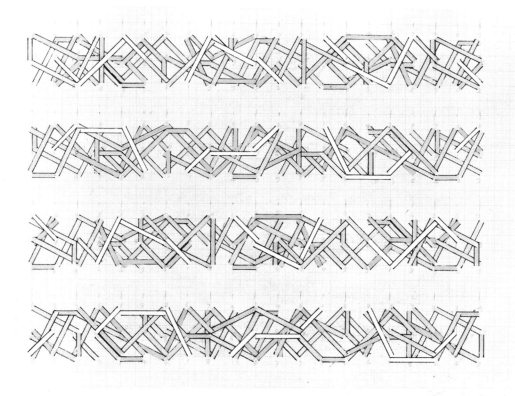

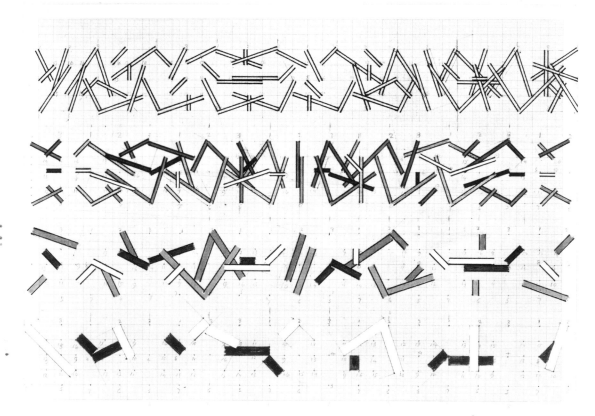

**45**
**Horizontal Rhythms (Metamorphoses) I** 1976

**46**
**Horizontal Rhythms (Metamorphoses) II** 1976

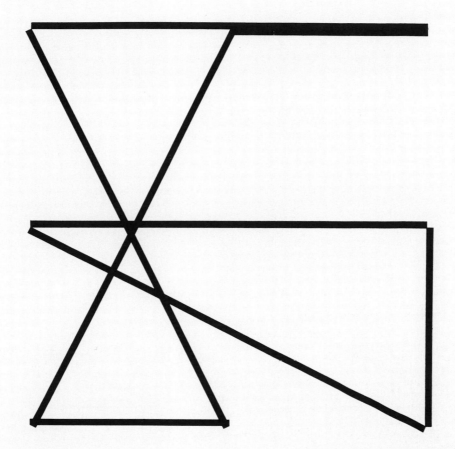

**47**
**Sequence of 9 Metamorphoses Drawings** 1977

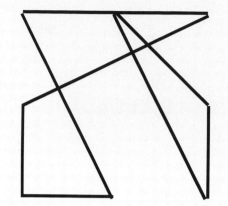

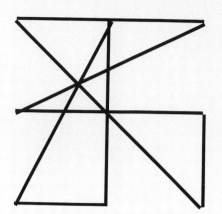

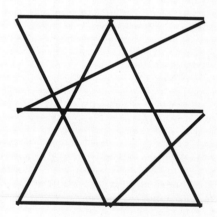

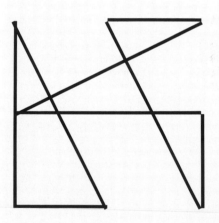

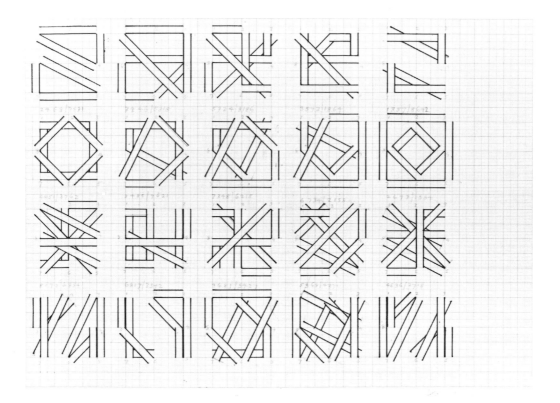

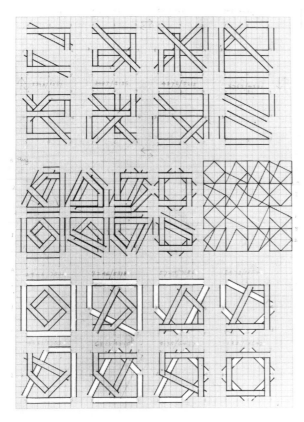

**48**
**Metamorphoses** June 1977
**49**
**Metamorphoses** June 1977

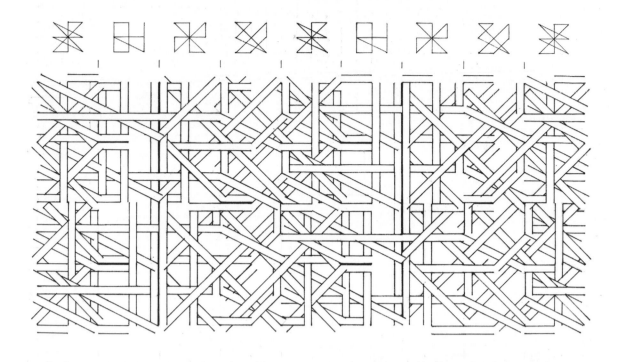

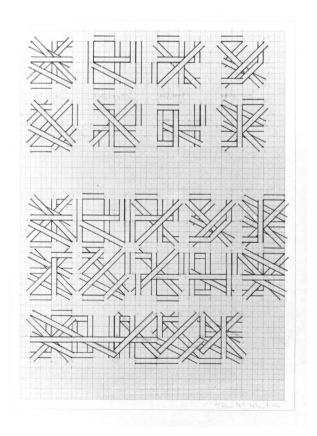

**50**
**Metamorphoses (Rhythms)** August 1977
**51**
**Metamorphoses** August 1977

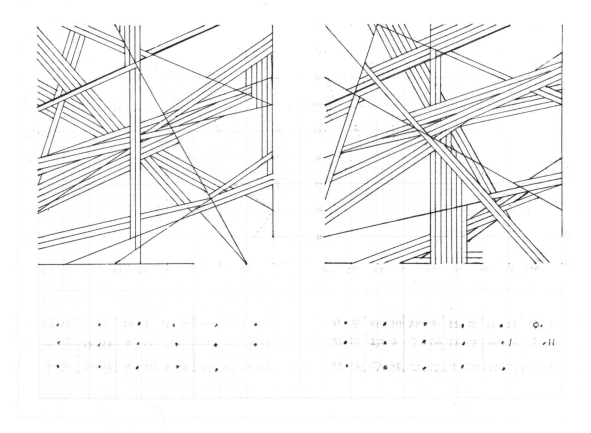

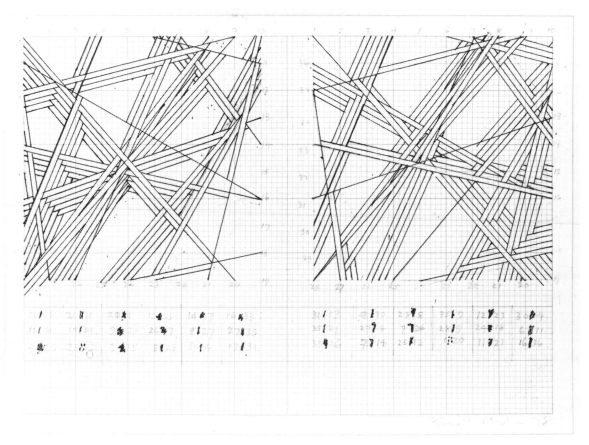

**52**
**Chance, Order, Change** 1978
**53**
**Chance, Order, Change** 1978

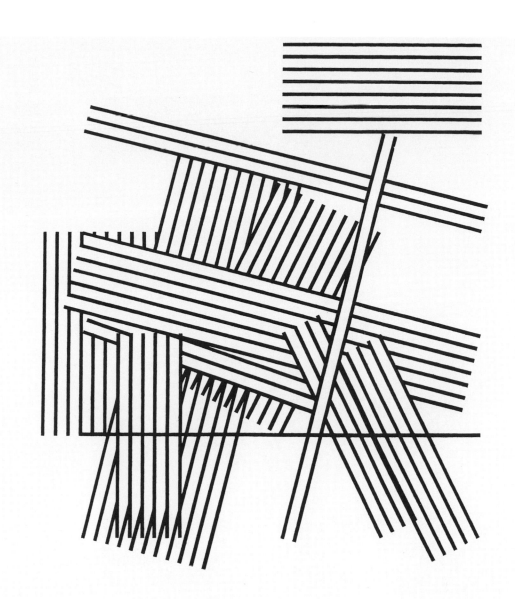

**56**
**Chance and Order 2** (Blue) 1970

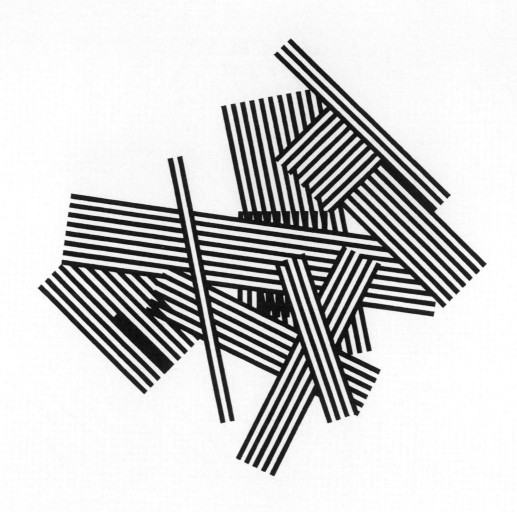

57
**Chance and Order 4** (Green) 1970

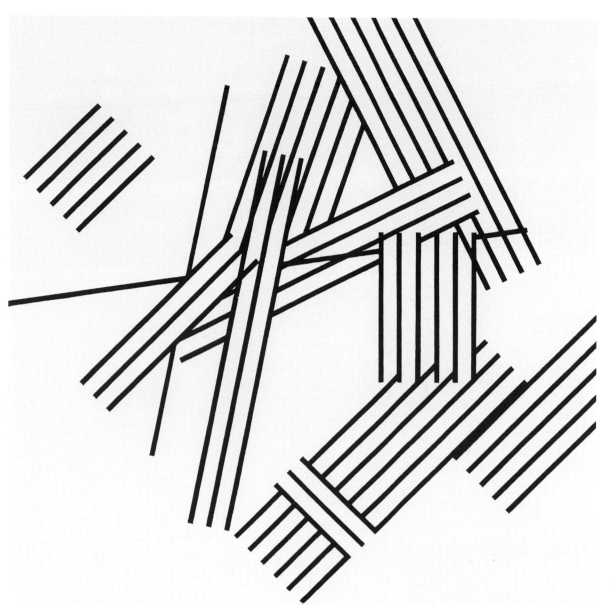

**58**
**Chance and Order 5** (Red) 1970

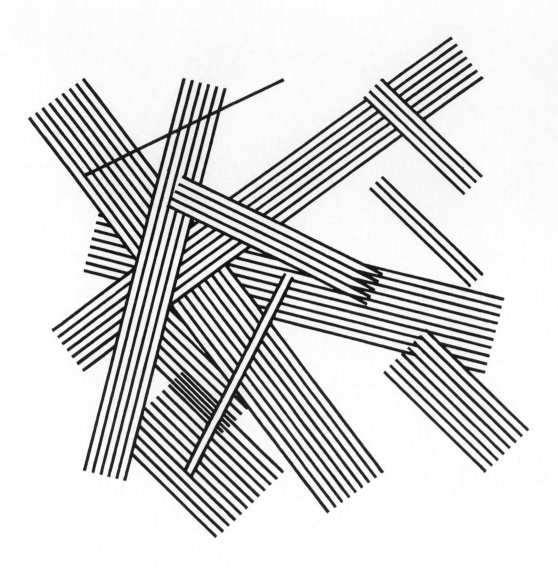

**59**
**Chance and Order 6** (Blue) 1970

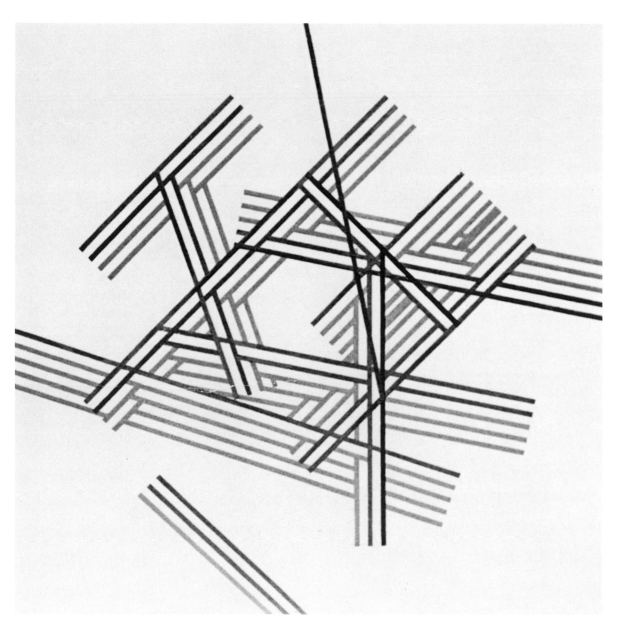

**60**
**Chance and Order 8** (5 colours) 1971

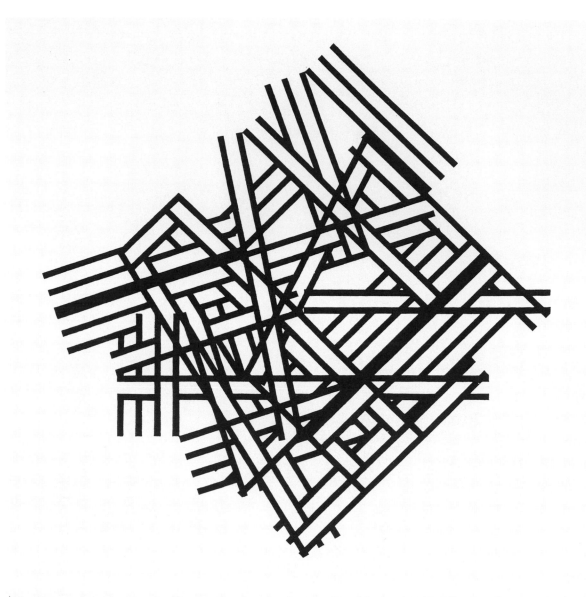

**61**
**Chance and Order 9** (Green) 1972

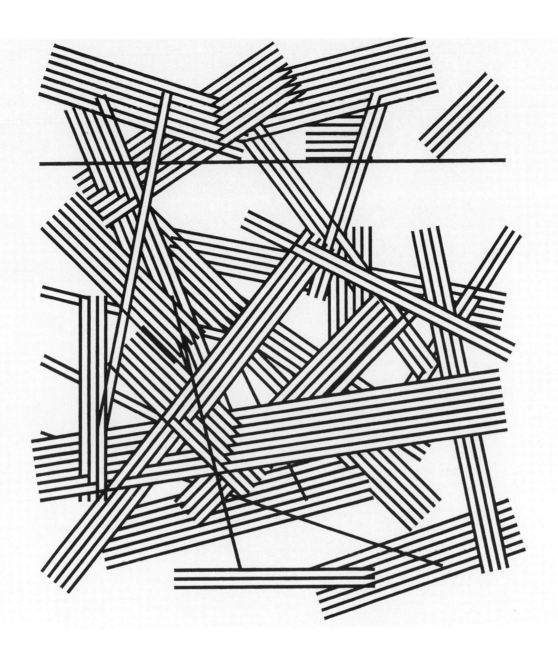

**62**
**Chance and Order 11** (Cobalt blue) 1972

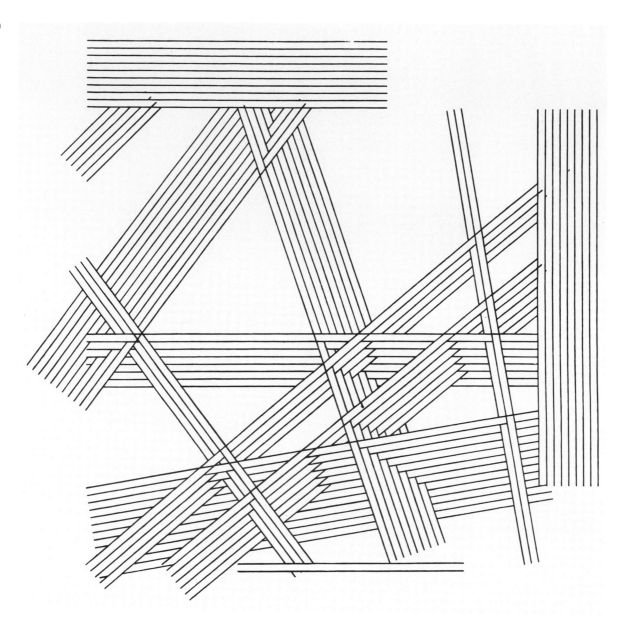

**63**
**Chance and Order 14** (Black) 1973

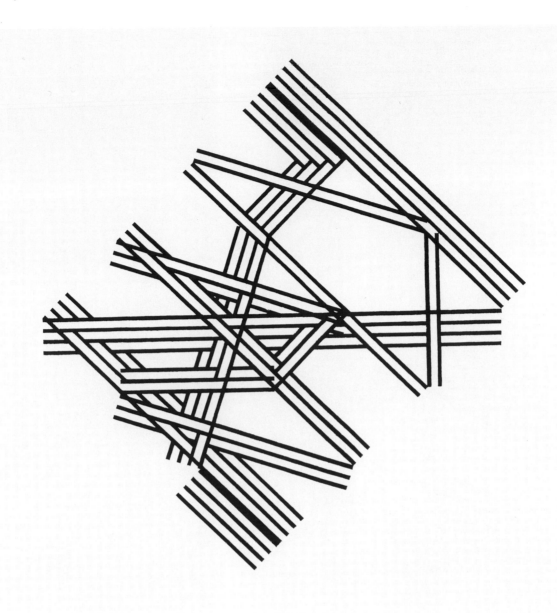

**64**
**Chance and Order 16** (Black) 1973

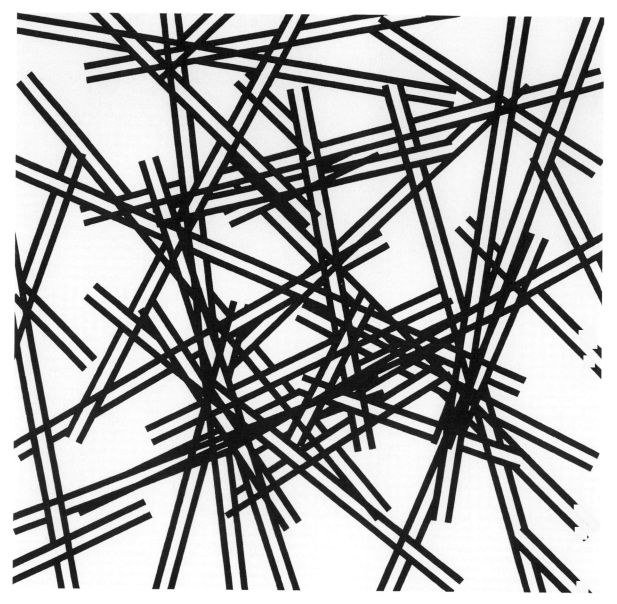

**65**
**Chance and Order 18** (Black) 1974

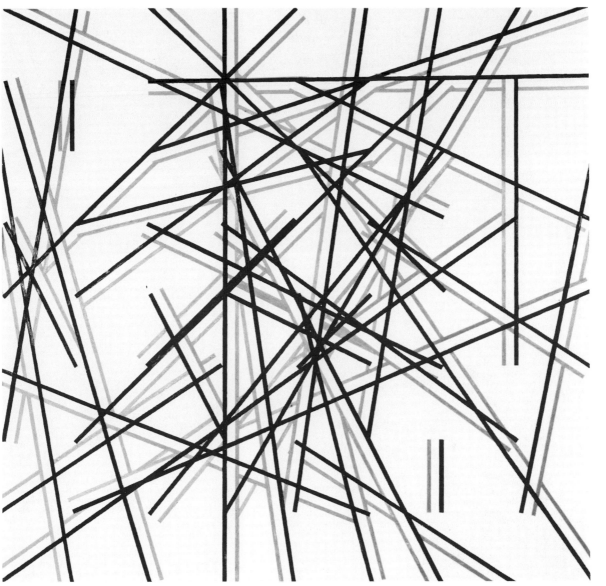

**66**
**Chance and Order 19** (Black and Red) 1975

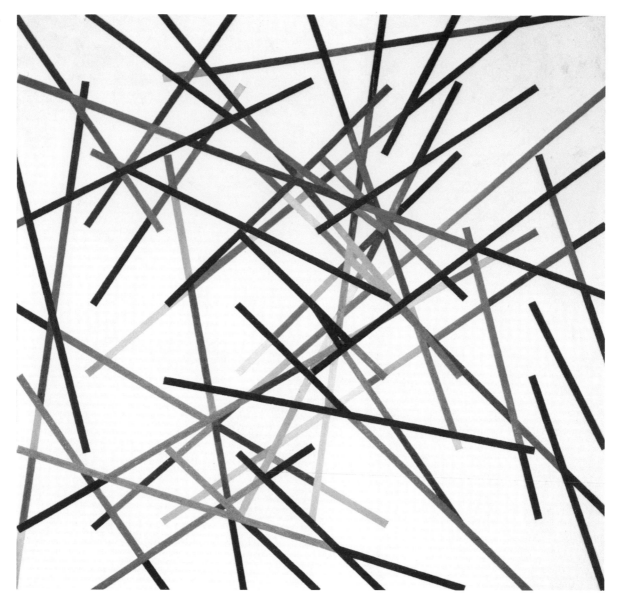

**67**
**Chance, Order, Change 1** (15 colours) 1976

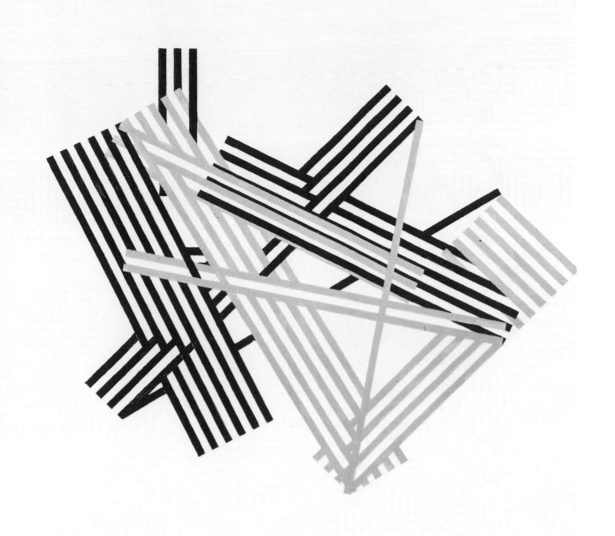

**68**
**Chance and Order 20** (Cobalt blue and Black) 1977

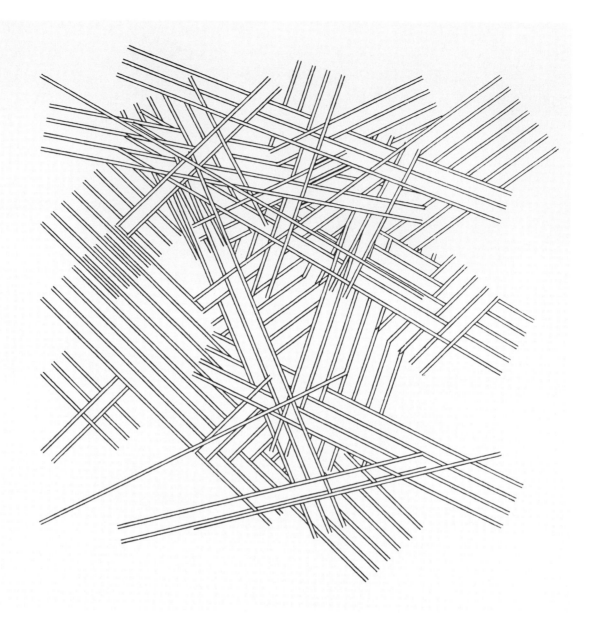

**69**
**Chance and Order 21** (Black) 1977-78

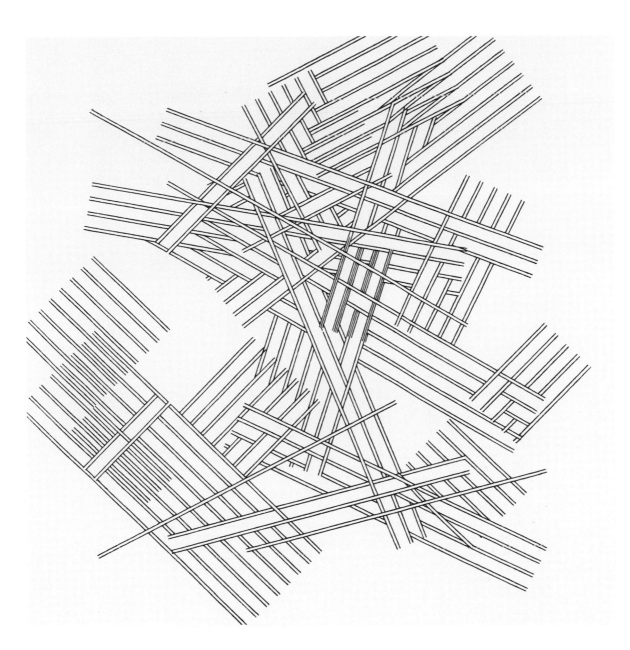

**70**
**Chance and Order 22** (Black) 1977-78

**71**
**Order and Change** (Black) 1977

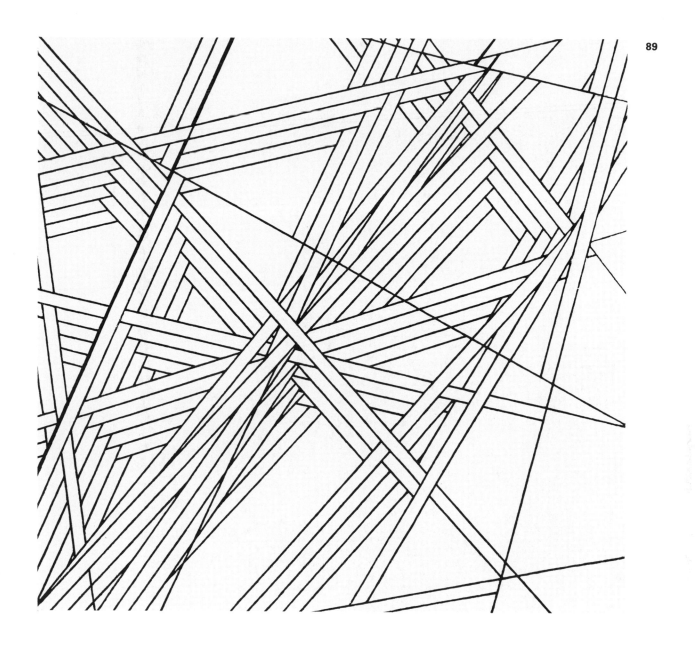

**72**
**Chance, Order, Change 4** (Monastral blue) 1978

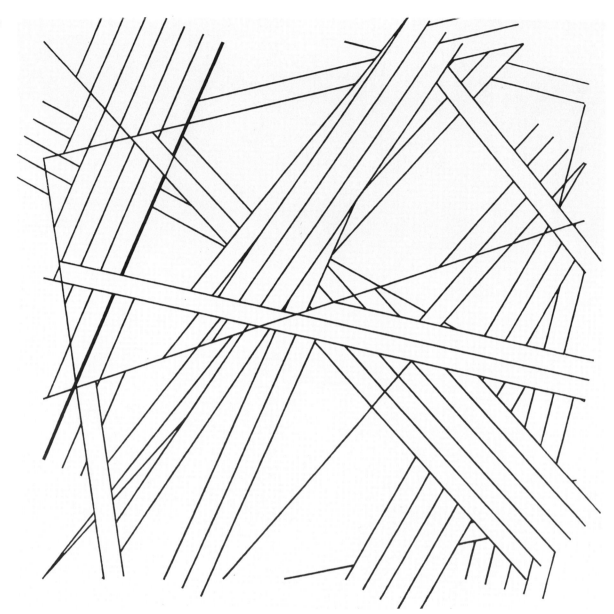

**73**
**Chance, Order, Change 5** (Ultramarine blue) 1978

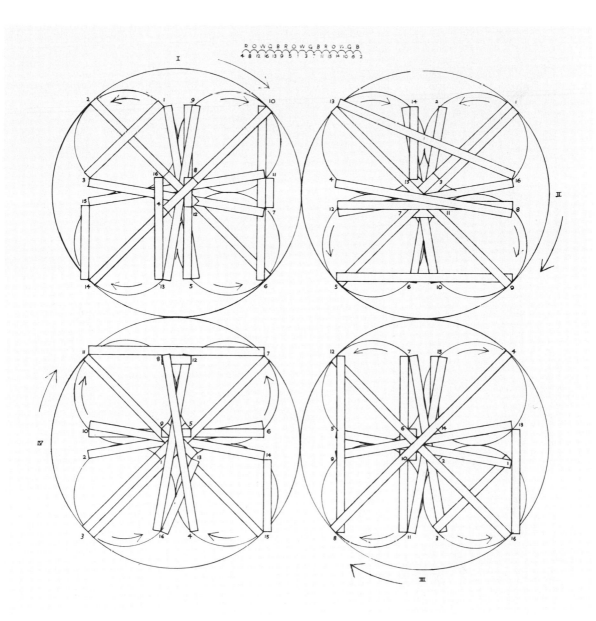

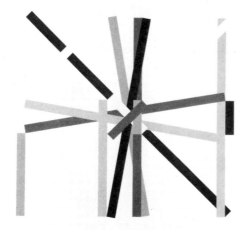

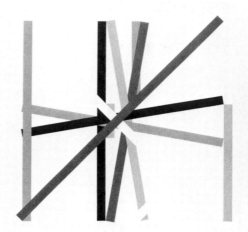

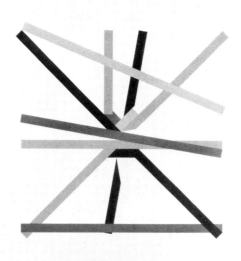

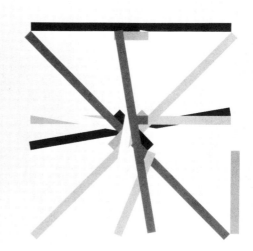

**75**
**Rotation "Frankfurt" I** 1977
**76**
**Rotation "Frankfurt" II** 1977

**77**
**Rotation "Frankfurt" III** 1977
**78**
**Rotation "Frankfurt" IV** 1977

métamorphoses 1976
kenneth martin

éditions média neuchâtel

**79**
**Metamorphoses** 1976
**80**
**Metamorphoses** 1976

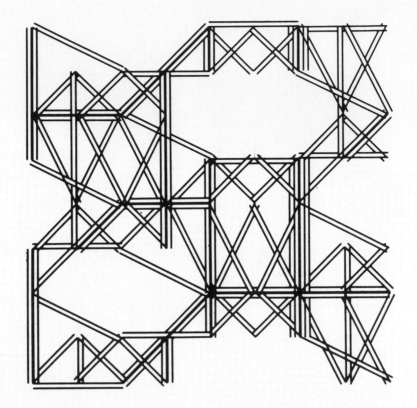

**81**
**Chance and Order (Black and White) VI** 1976

## Checklist

### Screw Mobiles

**1**
**Drawing for Screw Mobile** 1953
Pencil on paper
30 x 22 ins. (76.2 x 55.9 cms.)
The State Museum Kröller-Müller, Otterlo

**2**
**Screw Mobile** 1953
Brass and steel
33 x 12 ins. (83.8 x 30.5 cms.)
Stanley Picker, London

**3**
**Screw Mobile** 1953-73
Nickel-plated brass
26 x 11¹/₄ ins. (66 x 28.6 cms.)
Collection of the artist

**4**
**Drawing for Screw Mobile** 1955
Pencil and colored crayon on graph paper
30 x 22 ins. (76.2 x 55.9 cms.)
Lord and Lady Vaizey

**5**
**Screw Mobile** 1955
Phosphor bronze and steel
36 x 12 ins. (91.4 x 30.5 cms.)
Dr. and Mrs. O. Franklin

**6**
**Drawing for Screw Mobile With Cylinder**
1956
Pencil on paper
30 x 22 ins. (76.2 x 55.9 cms.)
Mr. and Mrs. Peter Lowe

**7**
**Small Screw Mobile** (3rd version) 1965
Brass
48 x 11 ins. (121.9 x 27.9 cms.)
Anthony P. Carter

**8**
**Screw Mobile** 1966
Brass tube and washers around a threaded
steel rod
13 x 19 ins. (33 x 48.2 cms.)
Juanita Kramer Bromberg

**9**
**Drawing for Screw Mobile** 1968
Pencil on paper
31³/₈ x 28 ins. (79.7 x 71.1 cms.)
Collection of the artist

**10**
**Screw Mobile** 1968
Brass
16 x 42 ins. (40.6 x 106.7 cms.)
John Martin

### Linear Constructions

**11**
**Four Lines in Space** 1959
Nickel silver
10 x 4¹/₂ x 4³/₄ ins., 13 x 8¹/₄ x 4¹/₄ ins.,
16¹/₂ x 5 x 5 ins., 10¹/₄ x 4¹/₂ x 6 ins.;
(25.4 x 11.4 x 12.1 cms., 33 x 21 x 10.8 cms.,
41.9 x 12.7 x 12.7 cms., 26 x 11.4 x 15.2 cms.)
Background of formica, perspex, blackboard
30 x 40 ins. (76.2 x 101.6 cms.)
Collection of New Orleans Museum of Art,
Gift of Mrs. Edgar B. Stern

**12**
**Line in Space** 1 1960
Phosphor bronze
12 x 5¹/₂ ins. (30.5 x 14 cms.)
Collection of the artist

**13**
**Line in Space** 2 1960
Phosphor bronze
12 x 5¹/₂ ins. (30.5 x 14 cms.)
Collection of the artist

**14**
**Linear Construction** 1961
Phosphor bronze, brass and wood
5³/₄ x 8 x 8 ins. (14.6 x 20.3 x 20.3 cms.)
Collection of the artist

**15**
**Linear Construction** 1961
Phosphor bronze, brass and wood
6³/₄ x 8 ins. (17.1 x 20.3 cms.)
Anthony P. Carter

**16**
**Line With Black Box** 1961
Phosphor bronze and painted wood
5¹/₂ x 4 x 3 ins. (14 x 10.1 x 7.6 cms.)
Collection of the artist

**17**
**Linear Construction** 1962
Brass and wood
7 x 8¹/₂ x 8 ins. (17.8 x 21.6 x 20.3 cms.)
Glynn Vivian Art Gallery and Museum,
Swansea

**18**
**Linear Construction** 1964
Brass and wood
11 x 8¹/₄ x 8¹/₄ ins. (27.9 x 21 x 21 cms.)
The Arts Council of Great Britain

### Oscillations

**19**
**Oscillation** 1963
Brass
8 x 5¹/₂ x 2¹/₂ ins. (20.3 x 14 x 6.4 cms.)
Adrian Heath

**20**
**Oscillation** 1963
Brass
10$^1/_2$ x 5$^1/_8$ x 2$^1/_2$ ins. (26.7 x 13 x 6.4 cms.)
John Weeks

**21**
**Oscillation** 1963
Brass
8$^3/_4$ x 5$^1/_8$ x 2$^1/_2$ ins. (22.2 x 13 x 6.3 cms.)
Anthony P. Carter

**22**
**Oscillation 'A'** 1964
Brass
10$^1/_2$ x 5$^1/_4$ x 2$^1/_2$ ins. (26.7 x 13.3 x 6.3 cms.)
The Arts Council of Great Britain

**23**
**Oscillation** 1973
Brass
17 x 3$^1/_8$ x 7$^1/_8$ ins. (43.1 x 8.6 x 18.1 cms.)
Collection of the artist

## Tunnels, Transformables and Variables

**24**
**Tunnel in the Air** (1st version) 1965
Brass
3$^1/_4$ x 6 x 3 ins. (8.2 x 15.2 x 7.6 cms.)
Collection of the artist

**25**
**Transformable** (2nd version) 1966
Brass
5 pieces: each 15 ins. (38.1 cms.)
Waddington Galleries Limited, London

**26**
**Variable Screw** 1967
Brass
13$^1/_4$ ins., greatest span 13$^5/_8$ ins. (33.6 cms., greatest span 34.6 cms.)
University of East Anglia, Norwich

**27**
**Variable** (Documenta Multiple) 1968
Brass on painted wood base
6$^1/_2$ ins. (16.5 cms.)
Collection of the artist

**28**
**Standing Linkage** 1970
Painted brass and wood
33 ins., greatest span 35 x 35 ins. (83.8 cms., greatest span 88.9 x 88.9 cms.)
Waddington Galleries Limited, London

## Rotary Rings

**29**
**Rotary Rings** (1st version) 1967
Brass
16$^3/_4$ ins., greatest radius 5$^3/_4$ ins. (42.5 cms., greatest radius 14.6 cms.)
Collection of the artist

**30**
**Rotary Rings** (2nd version) 1967
Brass
21$^1/_4$ ins., greatest radius 7 ins. (54 cms., greatest radius 17.8 cms.)
McCrory Corporation, New York

**31**
**Rotary Rings** (3rd version) 1967
Brass
36 ins., greatest radius 10$^1/_2$ ins. (91.4 cms., greatest radius 57.1 cms.)
Paul Martin

## Chain Systems

**32**
**Chain System** (2nd version) 1968-69
Brass with perspex base
3$^5/_8$ x 6$^7/_8$ x 4$^3/_4$ ins. (9.2 x 17.5 x 12.1 cms.)
Waddington Galleries Limited, London

**33**
**Chain System** (3rd version) 1968-69
Brass
3$^1/_2$ x 6$^5/_8$ x 3$^1/_4$ ins. (8.9 x 16.8 x 8.3 cms.)
Waddington Galleries Limited, London

**34**
**Chain System** (4th version) 1968-69
Brass
2$^5/_8$ x 5 x 5$^3/_4$ ins. (6.6 x 12.7 x 14.6 cms.)
Waddington Galleries Limited, London

**35**
**Five Times Five** 1970
Chromium plated brass
5 pieces: 1$^3/_4$ x 3$^1/_4$ x 3$^1/_2$ ins., 1$^3/_4$ x 2$^1/_2$ x 2$^1/_2$ ins., 2$^1/_2$ x 2$^1/_2$ x 2$^1/_2$ ins., 2$^1/_2$ x 2$^1/_2$ x 2$^1/_2$ ins., 3$^1/_4$ x 3$^1/_8$ x 2$^1/_2$ ins. (4.5 x 8.3 x 8.9 cms., 4.5 x 6.3 x 6.3 cms., 6.3 x 6.3 x 6.3 cms., 6.3 x 6.3 x 6.3 cms., 8.3 x 7.9 x 6.3 cms.)
Waddington Galleries Limited, London

**36**
**Broken Chain** 1968-70
Brass
2 pieces: 4$^7/_8$ x 9$^1/_2$ x 8$^1/_4$ and 4$^1/_8$ x 6$^5/_8$ x 7$^1/_4$ ins. (12.4 x 24.1 x 20.9 and 10.5 x 16.8 x 18.4 cms.)
Waddington Galleries Limited, London

## Chance and Order

## Drawings

**37**
**Chance and Order V/2** (circa 1969-72)
Pencil on graph paper
10$^1/_4$ x 8 ins. (26 x 20.3 cms.)
Waddington Galleries Limited, London

**38**
**Chance and Order VII/6** (circa 1969-72)
Pencil and ink on graph paper
13$^1/_2$ x 9 ins. (34.3 x 22.8 cms.)
The Trustees of the Tate Gallery, London

**39**
**Chance and Order VIII/6** (circa 1969-72)
Pencil and ink on graph paper
13$\frac{1}{2}$ x 9 ins. (34.3 x 22.8 cms.)
The Trustees of the Tate Gallery, London

**40**
**Chance and Order X/4** (circa 1969-72)
Pencil on graph paper
7$\frac{1}{2}$ x 11 ins. (19 x 27.9 cms.)
Waddington Galleries Limited, London

**41**
**Chance and Order X/6** (circa 1969-72)
Pencil on graph paper
12 x 8$\frac{1}{2}$ ins. (30.5 x 21.6 cms.)
Collection of the artist

**42**
**Sequence of 9 Chance and Order Drawings**
1974
Pen on graph paper
Each 9$\frac{7}{8}$ x 7$\frac{7}{8}$ ins. (25.1 x 20 cms.)
Collection of the artist

**43**
**Metamorphoses** 1974
Third of 3 sequences of 10 drawings each
Pen on paper
Each 9$\frac{7}{8}$ x 7$\frac{7}{8}$ ins. (25.1 x 20 cms.)
The British Council, London

**44**
**Series of 22 Drawings**
(commenced July 1976)
Ink and pencil on graph paper
Each 16$\frac{1}{2}$ x 11$\frac{3}{4}$ ins. (41.9 x 29.8 cms.)
Collection of the artist
Note: There are two drawings numbered 22.
In the second version the lines are doubled
and given a left-hand direction.

**45**
**Horizontal Rhythms (Metamorphoses) I**
1976
Ink, graphite and gouache on paper
11$\frac{3}{4}$ x 16$\frac{1}{2}$ ins. (29.8 x 42.0 cms.)
Fogg Art Museum, Harvard University,
Cambridge, Massachusetts, Purchase—
Margaret Fisher Fund for Drawings.

**46**
**Horizontal Rhythms (Metamorphoses) II**
1976
Ink, graphite and gouache on paper
11$\frac{3}{4}$ x 16$\frac{1}{2}$ ins. (29.8 x 42.0 cms.)
Fogg Art Museum, Harvard University,
Cambridge, Massachusetts, Purchase—
Margaret Fisher Fund for Drawings

**47**
**Sequence of 9 Metamorphoses Drawings**
1977
Ink on paper
Each 15$\frac{1}{4}$ x 11$\frac{1}{2}$ ins. (38.7 x 29 cms.)
Collection of the artist

**48**
**Metamorphoses** June 1977
Pencil and ink on graph paper
11$\frac{5}{8}$ x 16$\frac{1}{2}$ ins. (29.6 x 42 cms.)
Collection of the artist

**49**
**Metamorphoses** June 1977
Pencil and ink and gouache on graph paper
16$\frac{1}{2}$ x 11$\frac{3}{4}$ ins. (42 x 29.8 cms.)
Contemporary Art Society, London

**50**
**Metamorphoses (Rhythms)** August 1977
Pencil and ink on paper
16$\frac{1}{2}$ x 11$\frac{3}{4}$ ins. (42 x 29.8 cms.)
Private collection, London

**51**
**Metamorphoses** August 1977
Pencil and ink on graph paper
16$\frac{1}{2}$ x 11$\frac{5}{8}$ ins. (42 x 29.6 cms.)
Private Collection, London

**52**
**Chance, Order, Change** 1978
Pencil and ink on graph paper
8$\frac{1}{2}$ x 11$\frac{5}{8}$ ins. (21 x 29.6 cms.)
Collection of the artist

**53**
**Chance, Order, Change** 1978
Pencil and ink on graph paper
8$\frac{1}{2}$ x 11$\frac{5}{8}$ ins. (21 x 29.6 cms.)
Collection of the artist

**54**
**Chance, Order, Change** 1978
Pencil and ink on graph paper
8$\frac{1}{2}$ x 11$\frac{5}{8}$ ins. (21 x 29.6 cms.)
Private Collection, London

**55**
**Chance, Order, Change** 1978
Pencil and ink on graph paper
8$\frac{1}{2}$ x 11$\frac{5}{8}$ ins. (21 x 29.6 cms.)
Collection of the artist

## Paintings

**56**
**Chance and Order 2** (Blue) 1970
Oil on canvas
48 x 48 ins. (121.9 x 121.9 cms.)
The British Council, London

**57**
**Chance and Order 4** (Green) 1970
Oil on canvas
48 x 48 ins. (121.9 x 121.9 cms.)
John Weeks

**58**
**Chance and Order 5** (Red) 1970
Oil on canvas
48 x 48 ins. (121.9 x 121.9 cms.)
The Arts Council of Great Britain

**59**
**Chance and Order 6** (Blue) 1970
Oil on canvas
36 x 36 ins. (91.4 x 91.4 cms.)
Ferriel and Leslie Waddington

**60**
**Chance and Order 8** (5 colours) 1971
Oil on canvas
60 x 60 ins. (152.4 x 152.4 cms.)
Granada Television Limited, Manchester

**61**
**Chance and Order 9** (Green) 1972
Oil on canvas
36 x 36 ins. (91.4 x 91.4 cms.)
Galerie m, Bochum

**62**
**Chance and Order 11** (Cobalt blue) 1972
Oil on canvas
36 x 36 ins. (91.4 x 91.4 cms.)
Galerie m, Bochum

**63**
**Chance and Order 14** (Black) 1973
Oil on canvas
48 x 48 ins. (121.9 x 121.9 cms.)
Galerie m, Bochum

**64**
**Chance and Order 16** (Black) 1973
Oil on canvas
36 x 36 ins. (91.4 x 91.4 cms.)
Waddington Galleries Limited, London

**65**
**Chance and Order 18** (Black) 1974
Oil on canvas
36 x 36 ins. (91.4 x 91.4 cms.)
Collection of the artist

**66**
**Chance and Order 19** (Black and Red) 1975
Oil on canvas
36 x 36 ins. (91.4 x 91.4 cms.)
Collection of the artist

**67**
**Chance, Order, Change 1** (15 colours) 1976
Oil on canvas
48 x 48 ins. (121.9 x 121.9 cms.)
Ferriel and Leslie Waddington

**68**
**Chance and Order 20** (Cobalt blue and Black)
1977-78
Oil on canvas
36 x 36 ins. (91.4 x 91.4 cms.)
Waddington Galleries Limited, London

**69**
**Chance and Order 21** (Black) 1977-78
Oil on canvas
48 x 48 ins. (121.9 x 121.9 cms.)
Waddington Galleries Limited, London

**70**
**Chance and Order 22** (Black) 1977-78
Oil on canvas
48 x 48 ins. (121.9 x 121.9 cms.)
Private collection, London

**71**
**Order and Change** (Black) 1977
Oil on canvas
36 x 36 ins. (91.4 x 91.4 cms.)
Collection of the artist

**72**
**Chance, Order, Change 4** (Monastral blue)
1978
Oil on canvas
36 x 36 ins. (91.4 x 91.4 cms.)
Collection of the artist

**73**
**Chance, Order, Change 5** (Ultramarine blue)
1978
Oil on canvas
36 x 36 ins. (91.4 x 91.4 cms.)
Collection of the artist

**Prints**

**74**
**Key Drawing** 1977
Screenprint
$29^1/_4$ x $29^1/_4$ ins. (74.3 x 74.3 cms.)
Edition of 61
Waddington Galleries Limited, London

**75**
**Rotation "Frankfurt" 1** 1977
Screenprint
$29^1/_4$ x $29^3/_8$ ins. (74.3 x 74.5 cms.)
Edition of 61
Waddington Galleries Limited, London

**76**
**Rotation "Frankfurt" II** 1977
Screenprint
$29^1/_4$ x $29^3/_8$ ins. (74.3 x 74.5 cms.)
Edition of 61
Waddington Galleries Limited, London

**77**
**Rotation "Frankfurt" III** 1977
Screenprint
$29^1/_4$ x $29^3/_8$ ins. (74.3 x 74.5 cms.)
Edition of 61
Waddington Galleries Limited, London

**78**
**Rotation "Frankfurt" IV** 1977
Screenprint
$29^1/_4$ x $29^3/_8$ ins. (74.3 x 74.5 cms.)
Edition of 61
Waddington Galleries Limited, London

**79**
**Metamorphoses** 1976
Screenprint with overprinted text (text only)
$20^1/_2$ x $50^3/_8$ ins. (52 x 128 cms.)
Edition of 100
Waddington Galleries Limited, London

**80**
**Metamorphoses** 1976
Screenprint (without overprinted text)
20¹/₂ x 50³/₈ ins. (52 x 128 cms.)
Waddington Galleries Limited, London

**81**
**Chance and Order (Black and White) VI**
1976
Screenprint
27⁵/₈ x 27⁵/₈ ins. (70.2 x 70.2 cms.)
Waddington Galleries Limited, London

**Biography**

| | |
|---|---|
| 1905 | Born in Sheffield |
| 1921-23 / 1927-29 | Studied at Sheffield School of Art |
| 1923-29 | Worked in Sheffield as a designer |
| 1929-32 | Studied at the Royal College of Art |
| 1930 | Married Mary Balmford |
| 1946-67 | Visiting Teacher, Goldsmiths College School of Art |
| 1948-49 | First Abstract Paintings |
| 1951 | First Kinetic Constructions |
| 1965 | Gold Medal, President of the Italian Council of Ministers, on the occasion of the International Congress of Artists and Critics at Verucchio |
| 1969 | First CHANCE AND ORDER works |
| 1969 | Death of Mary Martin |
| 1971 | Awarded the OBE |
| 1976 | Honorary Doctorate, Royal College of Art |
| 1976 | Midsummer Prize, City of London |

**One-Man Exhibitions**

| | |
|---|---|
| 1954 | Heffer Gallery, Cambridge (with Mary Martin) |
| 1960 | ESSAYS IN MOVEMENT, ICA, London (with Mary Martin) |
| 1962 | Lords Gallery, London |
| 1967 | Axiom Gallery, London |
| 1970-71 | MARY and KENNETH MARTIN, Arts Council Tour of Great Britain |
| 1970 | Waddington Galleries, London |
| 1974 | Waddington Galleries, London |
| 1974 | Galerie Swart, Amsterdam |
| 1975 | Tate Gallery Retrospective, London |
| 1975 | Galerie m, Bochum |
| 1976 | Galerie m, Den Haag and Dusseldorf |
| 1976 | THE SCULPTOR AT WORK (with Henry Moore), Scottish National Gallery of Modern Art, Edinburgh |
| 1977 | Arts Council WORKING METHODS KENNETH MARTIN: DRAWINGS AND PRINTS |
| 1978 | Waddington and Tooth Galleries, London |
| 1978 | Galerie Lydia Megert, Bern |
| 1979 | Galerie Swart, Amsterdam |

**100 Mixed Exhibitions**

1951     BRITISH ABSTRACT ART, AIA Gallery, London

1954     ARTIST V. MACHINE, Building Centre, London

1956     THIS IS TOMORROW, Whitechapel Gallery, London

1957     STATEMENTS. A Review of British Abstract Art in 1956 at the ICA, London

1958     BRITISH PAINTING 1950-57, Arts Council, London

1958     DIMENSIONS. British Abstract Art 1948-57, O'Hana Gallery, London

1960     KONKRETE KUNST, Helmhaus, Zurich

1961     BRITISH CONSTRUCTIVIST ART, American Federation of Art. Touring USA. Organized by the ICA, London

1961     BEWOGEN BEWEGING, Stedelijk Museum, Amsterdam

1961     RORELSE I KONSTEN, Moderna Museet, Stockholm

1962     CONSTRUCTIVISME, Galerie Dautzenberg, Paris

1963     CONSTRUCTION, ENGLAND, Arts Council, London and touring Great Britain

1963     4th San Marino Biennale

1964     PAINTING AND SCULPTURE OF A DECADE, Tate Gallery, London

1965     8th Tokyo Biennale

1965     BRITISH SCULPTURE IN THE SIXTIES, Tate Gallery, London

1965     ART ET MOUVEMENT, Museum of Tel Aviv

1965     NOVA TENDENCIJA 3, Zagreb

1965     ART AND MOVEMENT, Arts Council, Edinburgh/Glasgow

1966     SOUNDINGS 3, Signals Gallery, London

1967     UNIT SERIES PROGRESSION, Arts Council touring exhibition

1968     CINETISME, SPECTACLE, ENVIRONNEMENT Maison de la Culture, Grenoble

1968     4 DOCUMENTA, Kassel

1968     ART AND THE MACHINE, University of East Anglia, Norwich

1969     KONSTRUKTIVE KUNST: ELEMENTE UND PRINZIPIEN, Nuremburg Biennale

1969     INTERVENTION DANS LA RUE, Centre Nationale d'Art Contemporain, Paris

| 1970 | KINETICS, Hayward Gallery, London |
| 1972 | NON-OBJECTIVE WORLD, Annely Juda Gallery, London |
| 1974 | BRITISH PAINTING 1974, Hayward Gallery, London |
| 1974 | BRITISH SCULPTORS—ATTITUDES TO DRAWING, Sunderland Arts Centre |
| 1974 | ASPECTS OF ABSTRACT PAINTING IN BRITAIN, Edinburgh Festival and Brussels |
| 1974-75 | ART AS THOUGHT PROCESS, Arts Council Tour and Serpentine Gallery, London |
| 1975 | INTERNATIONALE KLEINFORMAT-AUSSTELLUNG, Galerie Lydia Megert, Bern |
| 1976 | ARTE INGLESE OGGI, Milan |
| 1976 | RATIONAL CONCEPTS, English Drawings, Gorinchem, and touring Holland |
| 1976 | SYSTEM + PROGRAM, Warsaw |
| 1977 | RECENT BRITISH ART, British Council, Athens and touring Europe and the Middle East |
| 1977 | 6 DOCUMENTA, Kassel |
| 1977 | HAYWARD ANNUAL, London |
| 1978 | NUMERALS 1924-1977, Leo Castelli Gallery, New York; Yale University Art Gallery, New Haven and touring USA |
| 1978 | CONSTRUCTIVE CONTEXT, Warehouse Gallery, London and touring Britain; an exhibition selected from the Arts Council Collection |

## Commissions

| 1961 | Mobile for the International Union of Architects Congress Headquarters Building, London |
| 1961 | Fountain in Stainless Steel, Brixton College of Further Education |
| 1967 | Construction for the Nuffield Institute of Comparative Medicine at the London Zoo, Gulbenkian Foundation Commission |
| 1967 | Construction in Aluminium, Engineering Laboratory, Cambridge |
| 1972 | Peter Stuyvesant City Sculpture Project for Sheffield |
| 1974 | Fountain in Stainless Steel in Gorinchem, Holland made during the International Symposium in that town |
| 1977 | Kinetic Monument, Swansea, Wales |

**Public and
Corporate
Collections**

| | | |
|---|---|---|
| **British Isles** | Belfast | Ulster Museum |
| | Bristol | City Art Gallery |
| | Cambridge | Kettle's Yard, University of Cambridge |
| | Cardiff | National Museum of Wales |
| | Edinburgh | Scottish National Gallery of Modern Art |
| | Kingston-upon-Hull | Ferens Art Gallery |
| | Leeds | Leeds Education Authority |
| | London | Arts Council of Great Britain |
| | | British Council |
| | | British Museum |
| | | Contemporary Art Society |
| | | Department of the Environment |
| | | Tate Gallery |
| | | Victoria and Albert Museum |
| | Manchester | Didsbury College of Education |
| | | Granada Television, Limited |
| | Newcastle-upon-Tyne | University of Newcastle-upon-Tyne |
| | Norwich | University of East Anglia |
| | Salford | City Art Gallery |
| | Surbiton | Gala Cosmetic Group |
| | Swansea | Glynn Vivian Art Galery and Museum |
| **Iran** | Tehran | Tehran Museum of Contemporary Art |
| **The Netherlands** | Otterlo | The State Museum Kröller-Müller |
| **Portugal** | Lisbon | Calouste Gulbenkian Foundation |
| **United States** | Cambridge | Fogg Art Museum, Harvard University |
| | New Orleans | New Orleans Museum of Art |
| | New York | McCrory Corporation |
| **West Germany** | Duisburg | Wilhelm Lehmbruck Museum |
| | Essen | Folkswang Museum |

**Selected Writings
by the Artist**

'Abstract Art,' BROADSHEET NO. 1, Lund Humphries, London, 1951
'An Art of Environment,' BROADSHEET NO. 2, privately printed, 1952
'The Development of the Mobile,' 1955. Pub. Tate Gallery 1975
'Architecture, Machine and Mobile,' ARTS AND ARCHITECTURE, London, February 1956
'Invention,' 1956. Pub. Tate Gallery, 1975
'Mobiles,' ARCHITECTURAL DESIGN, London, October 1958
'Aim to take part in an expressive whole,' ARCHITECTURAL DESIGN, London, November 1961
'Fountain in Stainless Steel by Kenneth Martin at Brixton Day College,' ARCHITECTURAL DESIGN, London, February 1962
'Construciton from Within,' STRUCTURE, 1964*
Speech to International Congress, Verucchio, Italy, 1965*
'Kinetics,' VIEW, London, Spring 1966*
'Kinetic as a Constructing Process,' STUDIO INTERNATIONAL, London, February 1967*
'Construction and Movement,' ART INTERNATIONAL, Summer, 1967*
'Notes on work,' 1967. Pub. Tate Gallery, 1975
'The Construction as a Process,' 1967. Pub. Tate Gallery 1975
'Movement and Expression,' DATA, ed. by Anthony Hill, Faber and Faber, London, 1968*
'Richard Paul-Lohse: An Appreciation,' STUDIO INTERNATIONAL, London, February 1968
'Construction and Change,' LEONARDO, Vol. 1, Oxford, 1968*
'A Universal Kind of Art,' PERCEPTION, Birmingham, March 1969
'Scale and Change,' STUDIO INTERNATIONAL, London, January 1970*
'City Sculpture Project,' STUDIO INTERNATIONAL, London, Summer 1972
'Chance and Order,' ONE, London, October 1973*
'Naum Gabo,' ART MONTHLY, November 1977

*Republished, KENNETH MARTIN, Tate Gallery, 1975

**Selected Writings Relating to the Artist**

Lawrence Alloway, 'The Development of the Mobile,' ART NEWS, London, October 1953

Lawrence Alloway, NINE ABSTRACT ARTISTS, Tiranti, London 1954

Lawrence Alloway, 'Non-Figurative Art in England 1953,' ARTI VISIVE, Rome, January 1954

Andrew Forge, 'Notes on the Mobiles of Kenneth Martin,' QUADRUM 3, Brussels, 1957

Michel Seuphor, LA SCULPTURE DE CE SIÈCLE, Éditions du Griffon, Neuchâtel, 1959

Michael Middleton, DICTIONNAIRE DE LA SCULPTURE MODERNE, Hazen, 1961

Alan Bowness, Introduction to exhibition catalogue, Lords Gallery, 1962

J. P. Hodin, 'Une fontaine en acier inoxydable de Kenneth Martin,' QUADRUM 12, Brussels, 1962

Harriet Janis and Rudi Blesh, COLLAGE, PERSONALITIES, CONCEPTS, TECHNIQUES, Chilton Company, Philadelphia/New York, 1962

Denis Farr, BRITISH SCULPTURE SINCE 1945, Tate Gallery, 1965

Bryan Robertson, John Russell and Lord Snowdon, PRIVATE VIEW, Nelson, London, 1965

Anton Ehrenzweig, 'Kenneth Martin ed il Movemento,' D'ARS, 1-2, Milan, 1966

Andrew Forge, 'Some Recent Works by Kenneth Martin,' STUDIO INTERNATIONAL, London, December 1966

Paul Overy, THE LISTENER, June 15, 1967

A. M. Hammacher, MODERN ENGLISH SCULPTURE, Thames and Hudson, London, 1967

George Rickey, CONSTRUCTIVISM, ORIGINS AND EVOLUTION, Studio Vista, London, 1967

Frank Popper, ORIGINS AND DEVELOPMENT OF KINETIC ART, Studio Vista, London 1968

Alan Bowness, RECENT BRITISH PAINTING, Peter Stuyvesant Foundation Collection, Lund Humphries, 1968

Alistair Grieve, ART AND THE MACHINE, University of East Anglia, 1968

Edward Lucie-Smith, MOVEMENTS IN ART SINCE 1945, Thames and Hudson, London, 1969

Paul Overy, Introduction to Catalogue, MARY and KENNETH MARTIN, Arts Council touring exhibition, 1970-71

Conway Lloyd Morgan, Interview, 'The Martins/Museum of Modern Art,' ISIS, Oxford, May 25, 1970

Andrew Forge and Hilary Lane, CHANCE AND ORDER: DRAWINGS BY KENNETH MARTIN, Waddington Galleries, London, 1973

Marina Vaizey, 'Kenneth Martin,' THE FINANCIAL TIMES, February 26, 1974

Clive Phillpot, 'Feedback,' STUDIO INTERNATIONAL, April 1974

Paul Overy, 'Kenneth Martin after the forgotten years,' THE TIMES, May 20, 1975

William Packer, 'Kenneth Martin, Tate Gallery,' FINANCIAL TIMES, May 29, 1975

Paul Overy, 'The Work of Kenneth Martin,' STUDIO INTERNATIONAL, May/June 1975

KENNETH MARTIN, Tate Gallery, May 14-June 29, 1975, 2 volumes:
  Volume 1, Thirteen texts by Kenneth Martin written between 1955 and 1973;
  Volume 2, Essays written for the occasion by Joost Baljeu, David Bohm, Michael Compton, Andrew Forge, Gerhard von Graevenitz, Anthony Hill, François Morellet, Michael Morris and William Tucker

Michael Compton, 'Broadsheet for Kenneth Martin,' Tate Gallery, May 14-June 29, 1975

Arthur L. Loeb, rev. of CHANCE AND ORDER: DRAWINGS BY KENNETH MARTIN, Waddington Galleries, London, 1973, LEONARDO, Summer 1975

Stephen Bann, 'Kenneth Martin. Retrospective at the Tate Gallery,' STUDIO INTERNATIONAL, July/August 1975

Antje von Graevenitz, 'Grossbritannien, Tate Gallery Ausstellung Kenneth Martin,' PANTHEON, Autumn 1975

Colin Naylor and G. P. Orridge ed., CONTEMPORARY ARTISTS, Macmillan, London and New York, 1977

John McEwen, 'Sequences,' SPECTATOR, June 10, 1978

Anthony Hill, 'Kenneth Martin, Waddington and Tooth Galleries,' ART MONTHLY, July/August 1978

**Lenders to the Exhibition**

| | |
|---|---|
| The Arts Council of Great Britain | 18,22,58 |
| The British Council, London | 43,56 |
| Juanita Kramer Bromberg | 8 |
| Anthony P. Carter | 7,15,21 |
| Contemporary Art Society, London | 49 |
| Fogg Art Musuem, Harvard University, Cambridge, Massachusetts | 45,46 |
| Dr. and Mrs. O. Franklin | 5 |
| Galerie m, Bochum | 61,62,63 |
| Glynn Vivian Art Gallery and Museum, Swansea | 17 |
| Granada Television Limited, Manchester | 60 |
| Adrian Heath | 19 |
| Mr. and Mrs. Peter Lowe | 6 |
| John Martin | 10 |
| Kenneth Martin | 3,9,12,13,14,16,23,24, 27,29,41,42,44,47,48, 52,53,55,65,66,71,72,73 |
| Paul Martin | 31 |
| McCrory Corporation, New York | 30 |
| New Orleans Museum of Art | 11 |
| Stanley Picker | 2 |
| Private Collections, London | 50,51,54,70 |
| The State Museum Kröller-Müller, Otterlo | 1 |
| The Trustees of the Tate Gallery, London | 38,39 |
| University of East Anglia, Norwich | 26 |
| Lord and Lady Vaizey | 4 |
| Waddington Galleries Limited, London | 25,28,32,33,34,35,36, 37,40,64,68,69,74,75,76, 77,78,79,80,81 |
| Ferriel and Leslie Waddington | 59,67 |
| John Weeks | 20,57 |